1994

HOW
TO
GET
HUNG

HOW TO GET HUNG

A Practical Guide
for Emerging Artists

MOLLY BARNES

JOURNEY EDITIONS
Boston ∎ Tokyo

Published in 1994 by
JOURNEY EDITIONS,
153 Milk Street
Boston, Massachusetts, 02109

Library of Congress Cataloging-in-Publication Data

Barnes, Molly.
 How to get hung / by Molly Barnes.
 p. cm

 1. Art—Economic aspects. 2. Art—Marketing. I. Title.
N8600.B37 1994
706'.8'8—dc20 94-29432
 CIP

Cover painting, *The Inquisitor and the Imposter*, detail.
©1994 Russell Connor. Used by kind permission.

Text design by Jill Winitzer
Cover design by Kathryn Sky-Peck

ISBN 1-885203-08-X
First Edition
3 5 7 9 10 8 6 4 2

Printed in United States of America

Table of Contents

Foreword

Molly Barnes has been everything from artist to critic to art dealer to collector to curator to radio commentator, and she still has friends, so she must be doing something right. A glance at *How to Get Hung* reveals why: Barnes knows the art biz inside and out, loves it despite its myriad foibles, and wants to see people–especially artists–do well in it.

Sometimes glib but never cliched, sometimes cynical but never despairing, sometimes breathless but never foolish, Barnes is terse and to the point, disarmingly upfront with her advice and even with her gossip.

She puts all the negative things you've heard about the "art crowd" in proper perspective, and shows, finally, that art people are only human, too.

How to Get Hung isn't a dry manual showing you how to label slides or apply for teaching jobs; it's a perky little handbook of applied sociology, telling you what to expect from the characters you'll have to deal with if you want your art to reach a serious audience. You might not agree with every observation Barnes makes, but none is without merit.

There ain't no such thing as a recipe for success, in art as in anything else. But in *How to Get Hung* Molly Barnes has at least suggested a few ingredients, and some very handy tips on how to stir the pot.

—*Peter Frank,*
Editor of Visions *art quarterly and art critic for the* L.A. Weekly *and* Long Beach Press-Telegram.

Introduction

I love artists.

They are creative. Passionate. Poets of the future, visionaries. Individualistic. Committed. Caring. Idealistic, nonconformist, crazy.

The list is endless. Yet the very characteristics that I admire are often those that lead to conflict in the artist's life. Van Gogh would be great to visit, but I wouldn't want to leave my kids overnight.

How does the individual who locks himself in his studio for days on end reconcile working alone with haunting the environs of art dealers and getting his

work actually shown? How does the person who seeks to create new images but hates to balance his checkbook keep track of the business end of sales and selling?

Because art is two things: it is a love affair, and at the same time it is a business.

More than a billion dollars are generated yearly in art sales. Enrollment in art schools continues to rise; graduates, eager and ready to devote their lives to creating a memorable body of work, are joining the growing art scene. Today more people go to art museums than to baseball games. We see art in restaurants, shopping malls, dentists' offices, and parking structures.

As a love affair, it is personal, dynamic, and private.

As a business, it follows all the basic rules, plus those guidelines that are specific to art. Despite the more than 250,000 people who populate the art world, art remains a small one-to-one business. It is still laissez-faire. There is very little legislation dealing with art; the buyer must indeed beware. And despite the idealism of art, crooks lurk in shadowy corners. It is a business that attracts extremely competitive people and people who are seeking immortality. As an entrant in this arena, you will find few guides to protect you.

This book is about the practical side of art, about playing the game, about getting out of that studio and into the galleries. It is about the nuts and bolts of selling art. Some artists are offended by the idea that such a game has to be considered, but commercialism is,

however much you may despise it, an inescapable fact of contemporary art.

Yet even as we turn to the Philistine side of the artist's challenge, the essence of being an artist must never be forgotten. Creativity, individuality, commitment are at the root of everything you do. If you lose those as an artist, you lose your soul.

As an artist, you have a gift to give. Cling to that thought. Stamp it on your forehead. Tattoo it on your shoulder. Nail it to your doorpost.

When you attempt to get your work shown in a gallery or at an outdoor art fair or at your church, remember that you are bringing the audience something precious, and while you will always be appreciative and grateful for good response, it is you who are the giver.

Art is two things: it is a love affair, and at the same time it is a businesss.

It doesn't matter that your work has not yet been recognized. What you must have is a sense of your own potential, the vision you carry inside you that you have not yet had the opportunity to show to the world.

You also have a passion, an addiction, if you will. Art is not something you have a choice about. You *must* do it. Even if no one were ever to see your work, you would be painting away. Yes, art should be a dialogue

and there should be an audience, but if you were stranded on that fabled desert island, you would find a way to draw pictures in the sand.

So there you are, with the belief that you have a gift to give, with a sense of your own potential, and with the recognition that you have an addiction.

The next step, out of your home or studio into the larger art world, is a more practical one. It is one that arises more from practicality then from emotion. It is thinking rather than feeling.

I am assuming your talent, your potential, and your commitment fascinates you.

It is taking on the trappings of a professional. It includes everything from how to talk to art dealers to how to dress at openings to how to publicize yourself and your work.

I am assuming you have talent, potential, and commitment.

This book is about the work of being shown and known.

While you do the work—schmooze and calculate and struggle—let your belief in yourself remain your lodestar. After Jim McHugh photographed twenty famous California artists for Henry Hopkins' book, *California Painters, New Work*, he said that he had a sense of peace when he was with genuine stars like

Richard Diebenkorn and David Hockney, who have a core of honesty and spirituality that they are willing to protect at any price. Less successful artists, he said, are frequently angry and difficult, or they are obnoxiously lobbing slides, like hand grenades, at you at every possible opportunity.

Remember, as you follow suggestions in this book, that we are charting a course of what to *do*, not telling you what you *are* or must be. As an artist, you must always first be true to yourself and your vision.

Summary

As an artist, you
- ❏ believe in the gift you have to give.
- ❏ have a sense of your potential.
- ❏ recognize your art is an addiction.
- ❏ look and behave like a professional.
- ❏ keep your core of spirituality and honesty.

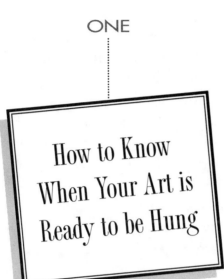

How to Know When Your Art is Ready to be Hung

When I was in the third grade, the class artist, Joel, could draw missiles. We all wanted to draw like him.

In art school the teacher raked me over the coals in class but let me hang out with her on weekends and after school and told me privately that I was lucky because I was the only one who got criticized.

After school I moved to New York and hung out with painters who were just beginning to make it: Willem de Kooning, Joan Mitchell, Robert Rauschenberg. I felt at home because they had feelings similar to mine.

If you paint every day, as I did, you have probably considered showing your work in a gallery.

The first questions you ask are, "Am I ready? How can I know when I'm ready?"

The answer is complex, not unlike Picasso's reply when he was asked how he knew when a painting was finished: "How do you know when you've finished making love?"

Intuitively, recognizing your gift and respecting your abilities, you may be sure in your heart that the time has arrived. At this juncture, practical guidelines should inform your decision.

First, you need a body of work. One lithograph, one collage, one sculpture, and/or one portrait do not a corpus of creativity make. They are sure signs of an amateur.

What you do need is *twelve to fifteen pieces that are united in theme, material, and size.*

A theme reflects a pattern of concern. You might be concerned with portraying a single person or specific time, as Mary Cassatt did with her portraits of Philadelphia society. Or maybe you're intrigued by color, as Kenneth Noland was with stripes, or maybe you are interested in gestural brush strokes, where the romance lies in the thickness of the paint, or the ways colors lead your eye around the canvas. Your work might be united by your materials, like decoupage, or clay, or resin and plastics. Any of these might be your unifying force.

If your pieces do not take their congruity from your subject matter, your style, or the materials you use, they might be integrated by their abstract concerns.

Like Ellsworth Kelly or Josef Albers, are you interested in exploring color relationships—where, for instance, yellow appears lighter when placed next to a dark color, and darker when placed next to a light color?

Is your art aimed at achieving optical tricks, as in Victor Vasarely's work, where the eye is titillated by the placement of primary colors next to each other? Or sculptures, like David Smith's, in which the junkyard detritus he used created a framing device so the negative space was as important as the material itself?

What you need to do is 12 to 15 pieces that are united in theme, material, and size.

Your pieces, taken together, should form an immediately recognizable coherent whole. They should reflect a harmony—not a disparity—of purpose.

Suppress the urge to include everything you've ever created. Do you really think a dealer's gaze will pierce a half-realized design and discover the gold buried there?

When you choose pieces to show, include only your best work. Do not risk diffusing your impact by presenting a scattered, disorganized series.

Unity of vision is powerful. Would you expect someone to concentrate on a book in which one chapter is science fiction, the next a dust-raising western, followed by a bodice-ripping romance and an ode in iambic pentameter? You have only to stand in a room full of Georgia O'Keeffe's work to grasp this concept.

Commit to one theme, and one theme that fascinates you.

Do not confuse yourself. Do not confuse your audience. Commit yourself to one theme that fascinates you.

How do you find a theme? A simple, four-letter word applies here: work. Work you brains and fingers out, and then work some more. Start each morning with six socially unredeemable drawings to exorcise your demons and then get to work.

Because art is an emotional medium with the uncanny property of transferring the artist's feelings to the viewer, follow a theme you feel driven by, no matter how strange or unconventional. Yvonne Jacquette painted the same corner of her living-room ceiling for two years until she had created a major documentation of the way the light hit the walls several times a day. Richard Diebenkorn looked out his studio window in Ocean Park, California, and painted the same alley repeatedly, abstracting the scene more and more each time.

Follow your obsession: the way chairs rest against fences, the relationship of primary colors, the history of New York diners. You'll know. You'll know because some unnamable gut feeling will keep drawing you back to the same theme.

When you approach your theme, you will discover an unpleasant reality: you will have to put aside everything that doesn't fit. That means the piece that took three years and gave you white hair and a divorce. Swallow hard—and stack it in the garage. Most likely, in years to come, your early work will make you cringe, and you'll be grateful for that garage.

Besides, there's always the chance that these pieces will form the germinal stages of your most important series. You can always go back later, unless the garage burns down.

How do you know what to eliminate?

Be bloody-minded and objective. Don't lie to yourself. In 1929 when Georgia O'Keeffe needed to find the next direction for her paintings, she took all of her work to a room at the Shelton Hotel in New York City and arranged it around the room, against the walls, on the dressers and desk. She spent two days in artistic solitary confinement, studying her older works as well as those in progress.

She made decisions. She decided to paint large canvases because no one was doing them at the time. She knew that the big canvases would draw some of the

attention she wanted. While her paintings took up more space, her images became simpler, concentrated on her theme—female forms that were mostly based on landscape imagery. She eliminated everything that was extraneous to her purpose.

In choosing a direction, become aware of what is current. In addition to perfecting techniques, an artist must work at keeping in touch with the art world. You must know the waters if you want to make a splash.

Dealers are looking for work that is on the cutting edge.

Before you sell your house so you can spend a year painting American flags, research. Dealers are looking for work that is on the cutting edge. Your work will not be well received if it appears imitative, no matter how loudly you protest the coincidence. When painters show me American flags, I say, "Betsy Ross and Jasper Johns have already done American flags to perfection."

National art magazines are a good way to keep abreast: check in *Art in America, Artforum, Art News, Flash Art, Art and Auction,* and *Art and Antiques.* The art sections of your newspaper and the Sunday *New York Times* are valuable for information.

Education is ongoing. You'll want to know contemporary vocabulary. Take "Figure grounding." Sculptors once worked like Rodin; they took a single clump of

material and shaped it. First Jacques Lipchitz, then Henry Moore, then David Smith came along and said that the negative spaces you see in the art are as important as the material itself. The term "figure grounding" came from World War II, when pilots learned to keep their views of the target fresh by looking at it and then looking away. Figure grounding is looking at the figure and then at the ground, and it is the way to look at sculpture. Viewing sculpture this way changes one's whole view. It's also known as gestalt—everything around being as important as the subject.

Or consider the vanishing point or Renaissance perspective, where everything moves toward a vanishing point in a mathematical formula. Critics like Clement Greenberg and France's philosophers Baudrillard and Derridá are read by young artists. They know the famous Columbia University philosopher/art critic Arthur Danto, who talks about inner compulsions as well as elitist clues and writes about Andy Warhol and Mark Tansey. Whether out of Yale or the West Coast's California Institute of the Arts, the learning beat goes on.

As for the work itself, what stage of development should your pieces be in before you show them to a dealer?

Finished.

All elements should be equally well developed. Concentrate on the background as well as the fore-

ground. A flower arrangement with no table under it and no wall behind it signals an amateur at work. The details of the background in a well-constructed painting are as important as the subject itself. Look at the details in the background of a Matisse or a Tom Wessleman, where the reclining figures are almost bland in comparison to the background.

A professional has developed a system of organizing and integrating space: the painting is an overall design that can be viewed upside down as well as right side up, pleasing because of the underlying structure. A vase floating in space is of no more use than sleeves without a bodice.

If your work has to be finished, won't you be on life support by the time it is ready to be hung in a gallery? No. Work around what you cannot do to compensate for areas of weakness. Let's say you can't paint hands. Your task is to conceive of an integrated piece that works beautifully without hands. For the sake of argument, let's say Diego Rivera couldn't get a handle on shading. So he avoided painting three-dimensional objects that demanded shading and instead concentrated on shapes of single color value. This is how a strong concept can eliminate the necessity of working with less-than-perfect skills.

When does the learning process, the selecting process, stop and the search to get hung begin? Some of you will find choosing this moment more difficult than

getting rid of the clay handprint ashtray you made in second grade. As the L.A. painter Helen Lundeberg has pointed out, "Some artists remain students, feeling most comfortable going from one guru to another."

If you want to settle for lavish praise from gurus, hey, that's fine. Your best friends will admire your work, and you can luxuriate in the untested notion that if you ever chose to put your work before the public, you'd be declared the most innovative talent of the time.

This view offers maximum security, but it is a false cocoon. Only by participating in the real world, by taking a player's role in the art scene and plunging through its torrents and ups and downs, only then do you grow. Only then does your art work grow and mature. Bernard Buffet suffered because he outlined flowers and street scenes and never moved on.

Finally, resist the temptation to talk about your work instead of doing it.

And that's what it's all about. If all artists refused to leave the safety of their nests, our lives would be void of such experiences as gazing at the Sistine Chapel or seeing Christo's fence. (Christo built a twenty-six mile long white fence in Northern California that extended through farms to the sea. The art was the conceptual process of selling the farmers and landowners on the idea as well as the documentation of the affair.)

Finally, resist the temptation to talk about your work instead of doing it. It is true that if all you do is chat you avoid creating pieces that deserve to be crushed in the disposal. You avoid those dreadful, gut-sinking, morale-lowering moments that come with unsuccessful experiments. You escape the numbing fear that comes with exposing your soul.

There is no substitute for work. Whether or not you have already found your form, your theme, the most important task you have is to keep at it. Keep experimenting. Keep exploring new territories. Keep defining new boundaries. Each new technique you master, each new material you solve, each problem you resolve extends your ability. The more you are capable of expressing the more you'll find to express.

Summary

❑ You are ready to show when you have twelve to fifteen pieces united in theme.
❑ You find a theme through trial and error and by pursuing what fascinates you.
❑ You prepare by researching so you don't duplicate the work of others.
❑ You include only your best work, eliminating the extraneous.
❑ You finish your pieces, don't cheat on backgrounds, and compensate for areas of weakness.
❑ You work instead of talk.

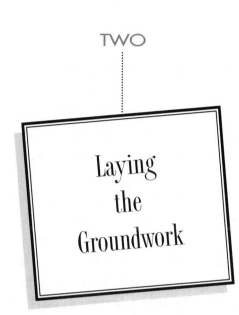

Laying
the
Groundwork

Artists are rebels who hate authority. Often they are loners painting to dreams known only to them. And that very individuality is part of what I love and treasure in artists—they are poets of the future. Their aloneness is what makes it possible for them to work isolated in their studios, where no one can tell them what to do or what to paint.

Still, art should be seen, and therein lies the conflict. As much as an artist needs to be true to his or her personal vision, there are social interactions to be performed to get that work seen, evaluated, appreciated and sold. The game, if you will, must be played.

More artists are successful because they can get along well with co-workers than because they are efficient at their job, as in other businesses. The old-boy network in the art world boosts favorites while the careers of equally talented artists languish. (It isn't what you know, it's who you know.) Success stories are filled with so-called breaks—someone who just happened to be in the right place at the right time. But often they knew what they were doing. For example, in order to meet de Kooning, I waited for weeks outside the East Hampton, Long Island, post office barefoot. I knew he loved Marilyn Monroe so I dressed appropriately. He came at the same time every day to pick up his mail and finally he spotted me and invited me to lunch.

And thus it is and always has been in the art world. Talent rarely is enough. Ninety percent of what will get you shown in a gallery is networking and strategizing. Donald Sultan's sister is a museum curator. The same with Claes Oldenburg's brother, Richard, who just retired from the Museum of Modern Art. There is work to be done to get your art seen that seemingly has little to do with the creative hours you spend in the studio.

Granted, many artists would prefer not to deal with the business of being an artist, but the facts of success are such that the path to interest a dealer in your work is circuitous and marked with many a seeming detour.

So look in the mirror, put on your artist duds, gear up, and hit the gallery walk.

PAY YOUR DUES

The pros of the art world like to feel newcomers have paid their dues.

When I first exhibited the painter and comedian Martin Mull, I ran into a great deal of resistance from other artists. Critics didn't want to review him, and the good-old-boy artists of the neighborhood didn't want anything to do with him. They thought that because he was a performer he was a dilettante and had taken advantage of his celebrity to get a showing.

Then they learned that he had studied at the Rhode Island School of Design. They found out he had managed to get his work shown in the men's room of the Museum of Fine Arts, Boston. He had studied. He had paid his dues. So they took him seriously, accepted him, reviewed him, and he is now being shown at the Dorothy Goldeen Gallery, one of L.A.'s finest art galleries.

NETWORK. . . NETWORK. . . NETWORK

I can't overemphasize the importance of circulating, and the best way to circulate is to go to art openings. The idea of networking is that when people see you at openings, they know you are willing to be in the game. Going to art openings is part of your job as an artist.

When you want to begin attending openings regularly, you can pick which ones to attend by checking art listings in your local papers; for example, the *Los Angeles Times* and the *New York Times* run the listings of shows on Fridays. Local papers may also carry other art opportunities. *Art Scene* magazine and the *Gallery Guide,* given out free at most galleries, carry news of openings. The West Coast magazine *Artweek* notes teaching jobs and summer schools for artists.

It will be easy to fill up your calendar with openings; plan to go to three or four a night. You will quickly know which shows are most apt to be helpful to you. There is little point in continually attending openings that do not draw your kind of artists or press or critics or collectors. However, that is always the chance of unexpected propinquity.

In addition to looking at the art, you are really there to meet people, who range from other unknown artists to famous artists to gallery owners to art consultants to collectors, and who exchange gossip—who's doing what to whom, who's gotten married, got a new gallery, changed studios, and so on. It was rumored that the collector Judd Marmor and his wife, Katherine, delivered George Herms's baby in

> If you talk to an artist, the most important words you can say are, "Let's exchange studio visits."

a field—that's how close collectors and artists can become.

Showing up at an opening is just the beginning. You want to make the most of your time there to lay the foundation for contacts that will help get your work known.

Go alone. A mate or friend is a distraction. It's too easy to talk to them instead of the strangers you need to meet.

Get there about an hour after opening time, which is usually 6:00 or 7:00 p.m. Look at the art and watch the crowd. Find someone who is part of the art world and strike up a conversation. (Don't go after the celebrities; everybody else is after them.) Find out your new friends' stories, their raps; let them get to know you.

If you talk with an artist, the four most important words you can say are Mark Kostabi's, "Let's trade studio visits." That means you'll go to their studios, sit on their rockers, make comments, or gossip about the local dealers. They'll do the same thing at your place another afternoon.

After you've chatted a few minutes at an opening, move on. Don't get trapped in long analyses and don't be too hasty to make dinner plans.

Don't discuss your personal problems; that's what therapists and support groups are for—not art gossip.

Don't overdrink. This is a business opportunity, not a social occasion. Keep your hidden agenda, which is to get to the dealer, in mind.

Sometimes this schmoozing is hard on the ego—a snooty put-down is an invitation to depression—but it is worth it. Art is a luxury business, and rejection is part of the game.

Through the grapevine you'll hear when the Ace Gallery in Los Angeles is looking for new people; you'll hear about new galleries soon to open; you'll learn who is to be trusted and who isn't, which galleries are slow to pay, and which don't pay at all; you'll be the first to hear about jobs available in the art world. You'll gradually become an insider.

I can't overemphasize the importance of circulating,.

Besides, sometimes the person you chat with may be the gallery owner, and you will be planted in his mind as a person who is serious about art. If you can, buy pieces you like. That's a sure way to become valued and open doors to get your art seen. Remember, prices are often negotiable, and you can frequently get a piece for considerably less than the announced price and buy it on time.

Keep your ears open for other ways to take advantage of openings.

The Los Angeles artist Laurie Pincus hung a large piece of butcher paper on the wall in the hallway of her house, and every time she came home from an art event, she wrote the names of the people she had met on the

paper and, using red and yellow lines, connected their names with others she had met previously and with whom they had a relationship. It was not only an interesting piece of art but a visual way for her to remember how she was moving along in the art world.

DEVELOP A STORY

A story is what you say when somebody asks you what you paint.

You should be prepared to talk about your work without having to think about it. If you've been working for twenty years and go blank when someone asks about it, you're in trouble.

Ask the artist Simone Gad, who supported herself for years by nude modeling at the Otis Art Institute in L.A., what she paints, and she might answer, "I paint celebrities who died tragically. I've painted Marilyn Monroe, the Beatles, and Elvis Presley. I've made collages of these people, and you can see some of these in the windows at such and such a gallery." There it is. Simone in a nutshell with a credit thrown in.

Willem de Kooning, who walked around with a copy of a book by the nihilist philosopher Ludwig Wittgenstein under his arm, could speak instantly of "shimmering glimpses," talking about the eternal realities instead of the minutiae of daily living that bog people down.

If you dawdle and mutter or are too self-centered, who will care about your work? If you are boring, your new acquaintance will be eager to move on.

Often it helps to practice with your family, or a professor at your school, or with someone who is articulate, or your support group, so when you run into an art dealer or possible buyer, you can spill your story quickly, succinctly, and clearly, and then shut up.

LOOK GOOD LIKE AN ARTIST SHOULD

Good-looking people get attention in every field, and the art world is no exception. And in this age, everybody can be good-looking.

You just have to get some clothes in a fashion that works for you. Get your hair styled in a look that suggests you are an artist. For example, the California arts commissioner Joan Quinn is distinctive with the streaks of purple in her hair that have become her trademark.

I was startled at a recent opening to hear a leading New York gallery owner, Mary Boone, scolding one of her artists. "I told you," she admonished him, "to dress in black, wear an earring and a cape, and have a two-day stubble." She wanted him to stand out as an artist, not look like just another guest.

If you are not naturally appearance conscious, get help. (If someone unexpectedly blindfolded you and

asked you what you were wearing, and you wouldn't know immediately, you are not appearance conscious.) An art consultant will be brutally honest about your getups, but if you don't have that access to clothing advice, go to Vidal Sassoon's student day or take advantage of some other beauty company's makeover offer. Explain to the beauty consultant that you want an "art look." People love to give advice, so listen like a student and learn without a lot of "Yes, buts." Try the new look out on friends and experiment. Gradually, or sometimes quickly, your style will emerge.

The L.A. sculptor Lita Albuquerque has great style with her black hair and flowing caftans. The artist Mark Kostabi looks on his clothes as an investment. He wants to be flashy (he thinks black is a cliché), so he wears a red Yohji Yamamoto jacket. Red is a dramatic color with a number of side effects. (Red cars are involved in more accidents than any other color of car.) Mark, who got into fisticuffs on air with Morton Downey, Jr., believes the fight would never have happened if he hadn't been wearing red. Since Mark's goal is to be known, the resulting publicity worked to his perceived advantage.

Mark's viewpoint has some historical credence. He points to photos of the Dada artist Marcel Duchamp and of Picasso, in his striped French sailor shirts, as examples of carefully planned, striking, unforgettable attire.

I go for the Junior League look because that's where

I came from and I'm comfortable with it, although I do think it's a little corny. I saw a video of myself at an art show I gave in New York, and I had to laugh. I looked like the person Candice Bergen played in the movie *Rich and Famous,* but still, it is the look I have chosen.

Francesco Clemente, whose goal is not to stand out, favors dark pin-striped suits or soft, unstructured jackets. Admirers of the German artist Joseph Beuys were often seen in little bowler hats. Some artists go for an ethnic look, such as the black image with corn rows or afros. If you have a great figure, dress to show it off. I suggested an artist to New York art dealer Larry Gagosian recently, and he immediately asked me, "Does she have a good figure?" Someone might complain "I'm above using that sort of thing," but I say, "use everything you can." Sex sells.

If you are not naturally appearence conscious, get help.

What the above artists have done is create a persona. Their clothes contribute to the image they hope to create; their appearance is distinctive and memorable.

Joan Simon, a Beverly Hills art dealer, claims a person can afford only one obsession: clothes, horses, or art. Since most artists suffer a shortage of funds, they buy art on time and shop at secondhand stores or haunt garage sales, preferably those held in the wealthier parts

of town, where clothes of quality are more apt to be found and the seller is less concerned about the bottom line. In Los Angeles, we have secondhand shops all along Ventura Boulevard in the San Fernando Valley. The same is true on Broadway in New York City. Enterprising artists will seek out shops in their own communities.

If you are not appearance conscious, take a friend with you as you seek your new look. Don't try to pattern yourself after some movie star, since most artists run about ten pounds heavier.

Artists must ask themselves, "Do I want to be rich or famous?" An answer to this will affect a lot of your personal decisions. Few artists care about money. They just want enough to paint and buy food and rent a studio. However, one does decide if one wants to be famous or rich, and if artists are honest most will admit that they want fame first and money will follow. If you decide to be famous, as did Julian Schnabel, you contentedly live in poverty, supporting yourself by being a restaurant cook, while becoming a household word. Whereas if you want to be rich, you follow the course of Peter Max, Luongo, Leroy Neiman, and Dali.

I believe the activities described above are essential steps for an unknown artist to take to break into the art world. Here are three more ways of enhancing your chances of being recognized.

DEVELOP A SUPPORT SYSTEM

Artists are often not good business people, so they should find someone to handle those sorts of activities for them. A wife, a husband, a parent, a friend—someone who will prevent you from getting bogged down in details that keep you from your work.

It's especially tough to break into the art world if you are a woman. Three of my favorites on the West Coast who have cracked that glass wall in my generation and lasted are Lita Albuquerque, Alexis Smith, and Judy Chicago. They are rare.

Some have beat that sense of aloneness by starting or joining support groups, of which there are many. Artist Deda Jacobson, for example, has a group in Los Angeles.

The late art lover and collector Marcia Weisman, Norton Simon's sister, gave classes in art education in her home. Her fees went to the student's favorite charity or museum, and it was an opportunity to share work and widen one's ever-expanding network.

One way to locate such a group in your area is to make it one of the questions you ask at art-gallery openings.

Hollywood wife Sandy Sallin couldn't stand the rejection she faced as a struggling artist, so she invited a group of women artists to meet weekly at her house. They shared the good and the bad experiences they

were having with one another and offered helpful tips. Sandy is now with the Koplin Gallery in Santa Monica, and the time she spent with her group before she could get shown was invaluable.

I cannot stress enough the importance of a support group for the synergism it offers—not only in support but in friendly competition. Joan Mitchell, a second-generation abstract expressionist, took me to meet all the good old boys of the abstract expressionist movement: de Kooning, Franz Kline, Robert Motherwell, Jasper Johns, and Rauschenberg. They all hung out together, had affairs with one another's lovers, gossiped, lent money and support, and became famous together.

This interaction is not a contradiction to my previous statement about wanting others to fail—that occurs outside the extended family, not within, where people pull for each other just as in a nuclear family. One of the differences between the art world today and the abstract expressionist days is that artists cluster in families today, instead of existing as tragic, lonely individuals fighting society alone. De Kooning used to piss on the beach in East Hampton, Long Island, and curse at the rich because he felt left out. Today, the rich court artists inside. The 1980s brought about the emergence of the monied collector calling the shots. Today, with the recession in art, people are returning to more healthy values, with artists as poets and heroes, and work about

political issues, painted by minority artists like the Guerilla Girls, is normal.

Plan to go one or two nights a week. In addition to looking at the art, you are really there to meet people, who range from other unknown artists to famous artists to gallery owners to art consultants to collectors, and who exchange gossip—who's doing what to whom, who's gotten married, got a new gallery, changed studios, and so on.

WORK IN AN ART-RELATED OCCUPATION

Even artists have to eat. And pay rent. And dress to go out in public. Et cetera, et cetera.

So you may not have the luxury of locking yourself in your studio and giving expression to your art. You may even be successful in another field—medicine or law or theater—and not want to give up that wonderful profession.

New York surgeon Joe Wilder is a person who combined two professions before segueing entirely into art. He was introduced to art by a patient, Zero Mostel, who saw his doctor as a workaholic who needed respite. The actor suggested Dr. Wilder take a life-drawing class in his studio, which met on Saturdays. The physician became so prolific and so proficient that he is now a fixture in the New York art scene.

In my own family, Steve Watkins thrives on his work as a lobbyist and paints evenings and weekends. There are hundreds of examples.

It's not easy to be a mail person or musician or librarian and try to set up a schedule to paint at night. In fact, it's darn hard. And art school doesn't offer classes on how to support your art habit.

When asked her advice on how to become a successful artist, Elaine de Kooning said, "Marry well." It helps to marry money, but even then your mate must understand the sanctity of your time. According to art dealer Douglas Chrismas of the Ace Gallery, there is an unfortunate tendency on the part of family and friends to think that because you don't go to an office with a boss who demands your time you are available for all sorts of things.

"Honey, would you mind running to the post office for me?" "Dear, could you paint the floor this morning?" "Jim, I'm going to head up a fund-raiser. Will you come to the meeting and give us some advice on materials? Maybe you could design our invitations."

Whether you are a full-time or part-time artist, the time you spend in your studio must be inviolate. Discipline must walk hand in hand with creativity.

But if you must be a part-timer—that is, you weren't born into a wealthy family and you didn't marry a rich mate and you don't have a professional career you can afford to give up—consider getting a job in an art-relat-

ed field: hang pictures, design for a graphic arts agency, get employed by an art gallery, frame shop, art museum, or art supply store. Cater food for art openings. Become a receptionist in an art gallery. Ship art. Make that job work for you and your career.

Take an occupation like trucking, for instance. L.A. artist Richard Klix started the Cart and Crate shipping company with his wife. Painter Chuck Arnoldi began by transporting art, as did the Dill brothers, Guy and Laddie John Dill. Men who work for companies that move art have great access to information. No one pays much attention to them, so they pick up a good deal of inside information and consequently know when to make a move to put their art forward.

Some art-related jobs provide an opportunity for growth as well as networking.

An aspiring artist friend's first job was at a Los Angeles gallery, where she was able to take her paintings in and have them critiqued. She could see what she was doing wrong and how amateurish her work was: she did flower arrangements and left out the background; she painted people and left out their hands because she wasn't good with hands; she didn't have a point of view.

Besides getting free art consultation in a gallery job, you have access to the major collectors. When I worked for the Feigen-Palmer Gallery in Los Angeles as a young person, I heard Billy Wilder talk about "wall power"

(consequently, I named my first company Wall Power). I heard actor Vincent Price talk about the necessity of humor in an art collection and Edward G. Robinson talk about owning the perfect Georges Rouault. I was able to observe how dealers court collectors, how they become part of the family—go to bar mitzvahs and weddings and funerals—and how that pays off in being able to get those collectors into galleries. (If someone in the art world invites you into their life—asks you to be a godparent or whatever—do it. It's all part of strengthening your network.)

LIVE IN NEW YORK CITY

In buying real estate, goes the cliché, there are three primary considerations: location, location, location.

Some pros, such as Los Angeles County Museum of Art new-talent award-winner Jim Morphesis, feel this is also true of the art world. Location is all, and location is New York City, New York City, New York City. Art is taken more seriously there than anywhere else; everywhere else you are just waiting to get the reviews from New York. There simply aren't as many respected art journalists in other parts of the country.

Jim Morphesis is not alone in his opinion that New York is where it's happening. New York is where most of the major art critics live and where the art magazines

are published. The competition is fierce, but the synergism is terrific. You up the odds of the "coincidence" of being in the right place at the right time. When you live in New York City things just happen.

Yet, this is not necessarily the only place where this happens. Los Angeles artists feel their city is the center of the art world. And there are successful artists who have chosen to live far from either maddening crowd. They might live in El Paso or Boise. Chicago offers things New York can't. L.A. offers space and freedom and a more laid back quality than New York.

You have to answer for yourself when is the right time to move to New York. Arnold Mesches did move in his late forties. Jim Morphesis in his thirties. Most do it right out of college or art school.

Georgia O'Keeffe's choice of New Mexico as a home base is a famous example. Fritz Scholder is from the southwest. Mark Tobey lived in Seattle, and Wayne Thiebaud lives in Sacramento, California. Bruce Nauman and Susan Rothenberg live in Texas. Wonderful pop artist Marcia Gygli King began in Texas before going to New York.

It is true that these artists maintain some sort of relationship with New York. In these settings, keeping up with art magazines takes on even greater importance.

Summary

Before that first show you may become a part of the art community by:

❑ Becoming actively involved in the art world.

❑ Attending art openings.

❑ Exchanging studio visits with other artists.

❑ Buying art.

❑ Dressing to develop your persona as an artist.

❑ Developing a story.

❑ Developing a support system.

❑ Working in an art-related occupation.

❑ Moving to New York— or growing where you're planted and developing your network there.

Preparing to Present Your Art

Paying dues. Networking. Looking good.

All this activity is leading someplace, and that place is a gallery or an alternative space. A space that hangs your work.

Sure, it would be terrific if, as with Lana Turner in the drugstore of Hollywood mythology, a gallery owner saw one of your paintings and offered you a showing. In this fantasy, critics and collectors discover you. That's it. You are rich and famous with Robin Leach. Leo Castelli wants you. You're written about in *Time* magazine by Robert Hughes. You are invited to show at the Whitney Biennial.

You may also win the lottery or get struck by lightning.

More realistically, you will take practical action to get your work seen.

First, as we have discussed, you need to pick your body of twelve to fifteen pieces united in theme.

Musician Bob Crewe made millions of dollars writing such popular music as "Can't Take My Eyes off of You," but he had a visual side as well. He loved collages and wood; he loved the masculine quality of chopping wood and creating the collages. The problem was he had so much to say that he would pull hundreds of little pictures out of *Life* magazines and keep adding them as idea after idea poured out.

I suggested first that he simplify his image. He loved big, bold shapes, but he was working in a tiny living room, so every time guests came he had to put everything away. He needed a studio.

The size of an artist's working space is important. He first bought a small apartment next door to his own, but it had a low, cottage cheese ceiling, and the space didn't begin to give him the room his interests required.

So he took a large sound studio in East Hollywood gutted it, painted it white, and began working in an area large enough to accommodate his large vision.

It wasn't long before he was ready to show his work, and his music friends not only came to see but stayed to buy.

As you begin eliminating the extraneous from your work and making choices about what you will show the dealer, the questions of matting, framing, and signing come up.

Signing your name on the front of the canvas is out of favor at present. It fell into disfavor because artists felt the name called attention to itself and was disturbing to the surface of the canvas. As paintings moved away from pictorial or narrative art, into abstraction—more specifically, how color was pushing into the room—artists felt, rightly or not, that they shouldn't have to have their signature on the front, calling attention to the lower right-hand side of the painting. Thus, contemporary artists either don't sign at all or sign on the back when the work is done.

Eliminate the extraneous from your work.

It is hoped, after all, that an artist's signature is in the painting he or she has done, and sometimes a buyer will ask that the artist sign the painting when it is purchased. Billy Wilder, the Hollywood director asked me to get Larry Rivers' signature on a watercolor he had purchased. I tracked Larry down during an art lecture he was giving at the Otis Art Institute. Before the audience, Larry dramatically broke the glass in the frame and signed the picture.

As for framing, you may want to save that decision

until the gallery owner is at your door making a commitment for a show.

In the old days there were traditions in framing, like those in fashion or in headlines. Before 1943, everything was framed in ornate gold frames or mahogany or other wood, often with a name plaque and a pin spotlight on top of the frame.

Don't have your slides done by an amateur.

The idea then was that everything was aimed at taking your eye into a kind of theater or arena. The concept was like that of the Renaissance perspective, with everything going toward a vanishing point—usually in small paintings.

When the abstract expressionists started painting, in the forties, they began using immense canvases. Like Jackson Pollock, they actually painted on the floor and then mounted the work on stretcher bars later. Or they would paint large canvases directly on the wall. The idea was to bring the work out into the room, to make it become an organic part of the room. In fact, because artists were painting in lofts with small freight elevators, sometimes they painted on two canvases which were hung flush, next to each other, in galleries.

Using bright colors, the abstract expressionist painter would set up a field of energy. For example,

when Mark Rothko painted a brush stroke with a cool color on the spectrum like black, blue, or grey, over a hot color, like red, the red pushed the cool color forward. The abstract painters like Rothko knew how colors would react and change when placed next to other colors and used this to make the painting jump and move. Everything in the abstract genre is designed to bring the energy of the painting into the room. Thus, today framing is rare, because, without a frame, the wall is nearly flush against the painting and the effect of the painting moving out into the room is further enhanced.

Before your first show, it is best to have your paintings just on stretcher bars. It is not always wise to mix framings, which can be just as distracting as not having unity in your choice of paintings.

SLIDES ARE ESSENTIAL

The time to have them made is when you have your body of twelve to fifteen pieces that are united in theme. (But you may want to shoot as many as twenty-four slides; that way you can show your progression toward the style to which you have evolved.)

Don't have your slides done by a well-intentioned amateur friend or even by a talented friend who is not familiar with shooting artists' works. You don't need

slides that are out of focus or shot in the sun, and you don't need background details in the photo. You don't need your hand or your friend's dog's tail in the shot.

You don't want pictures taken with you standing in front of your work; it brands you as a dilettante and sends a signal that you don't believe in your art. Just get the image. Avoid the frame—unless the frame is an integral part of the piece. British artist Michael Vaughn, for example, paints shadows on his frames.

The crucial key is to get a professional look. Your work will show best when it is shot against a black or white wall, seamless kraft paper, or even black velvet.

The crucial key is to get a professional look.

If you can afford to pay four or five hundred dollars, have the slides done by a professional. They are worth every penny.

Because of the expertise of these professionals, they will be able to put your art's best look forward. Besides, you are adding to your networking family, getting on the grapevine, wending your way into the art world.

If you don't have that kind of money available, there are other options, such as making a trade. Go to the photography department of an art school and post a note on the bulletin board that you will trade art photographs for a piece of work. There are always good deals to be made with somebody studying to be a professional. This is not unlike getting your hair styled—

that is, getting a cut at Vidal Sassoon's on the days when students are cutting at bargain rates but are doing a professional-level job.

Make eight to ten copies of each slide (duplicates run about thirty-five cents each). You're going to be sending them or delivering them to art dealers, your mother, anybody who wants to see your work.

Slides are necessary, but even better are 4″ x 5″ color transparencies, which make it much easier for a dealer or interested person to see your work. Another bonus is that when you have your show, they can be reproduced for publication.

You will either be sending slides or delivering them. When you mail slides, be sure to include a stamped, self-addressed envelope. That way you have a fighting chance of getting your slides back. Without that self-addressed envelope, your slides will be headed for the wastepaper basket.

Dealers often have slide projectors in their galleries, but you can go them one professional step better—and enhance your image as a pro—if you take your own light table, with a surface of about 8″ x 11″, which is good for showing either slides or color transparencies. Buy one at a photography shop or an art store.

However, even if you purchase a light table, you still need to learn how to use a slide projector. If a dealer wants to see your work, you don't want to fumble with the projector.

Since slides must be put in the projector upside down, draw an arrow on the right side of the slide pointing up, so you will always know which is the right side up and which side should go into the projector. With abstract art, the arrow takes on compelling importance, since the viewer will have no idea of what is up and down.

When you get your slides, mark them immediately. Also, stamp your name, address, and telephone number on the side or back of the slide. Across the bottom, put your name, the title, the medium (oil on canvas, o/c, acrylic, ac/c), the size in inches (height first, then width, then depth if it is a sculpture), and—very important—the date. For example, a legend might read: "Roy Lichtenstein, *Mona Lisa Crying,* ac/c, 39″ x 34″, 1987."

Artists may transcribe this information onto the slide holder using any medium, but a highly professional artist, such as Daryl Fussaro, spends a few dollars on a stamp, which makes for neatness and clarity and, again, a look of professionalism. As I write this, his slides sit here side by side with those of an artist who has written her information in soft pencil. If these two batches sit in front of an art dealer, you don't need three guesses to see whose art will be taken the most seriously.

Art is such an ephemeral thing that anything you do that shows you are a professional is one more plus in your asset column.

Register your slides at museums as well as alternative spaces. For example, the Los Angeles Municipal Art Gallery, in Barnsdall Art Park, houses the Cultural Affairs Department Slide Registry for professional artists who are residents of Southern California. To be included in the registry, artists may write or call the Municipal Art Gallery for information and an application form.

To be put on the mailing list to receive information on upcoming art exhibitions presented by the Cultural Affairs Department, artists can call or write the department's main offices or the Municipal Art Gallery. To donate art to the City Art Collection, send a letter to the curator of the City Art Collection at the Cultural Affairs Department. You will receive papers to fill out on your background and experience, and you'll be in the art loop.

Register your slides at a museum.

A profitable rental program goes on at the Los Angeles County Museum of Art. Participants are picked by a strict selection process. Artists submit biographies, which are reviewed every two weeks by well-qualified volunteers who know what is selling in the art world. If your slides meet their standards, they'll pay your studio a visit and consider putting your work in a show. They answer every request. They may be taken by anything

unusual or something environmental (political is proper) or something avant-garde. Often they are looking for work that will fit in a planned theme show, and you might be lucky enough to be painting a hot topic at the right moment.

The County Museum also has a new talent award for artists under thirty-five, for which you can submit a résumé and slides. The artist selected might already have had an art show or shows but never had museum exposure. The winner of the new talent award is given a special show at the museum, as well as ten thousand dollars and invaluable exposure. James Morphesis, a successful New York artist, started this way.

Your own art show may be the epitome of your dreams, but you don't need to wait until that show to have your work seen.

GET YOUR WORK SHOWN IN OTHER VENUES

This is a marketing task. You're getting out there and selling yourself and your work. Not only will you find ways to exhibit your work, but the very pursuit of possibilities will help you to get a focus on showing your work. It is good practice for winning an art dealer and your first gallery show.

There are many places to show your art. Consider the possibilities:

- airports
- banks
- charities
- clubs
- frame shops
- theaters, movie houses
- Schools, even your kid's school
- lobbies of corporations, beauty parlors, health spas

- art fairs
- car washes
- churches
- dance studios
- hotels
- restaurants, coffee shops

These are places. There are also people who can open doors:

- architects
- graphic designers, interior decorators
- realtors

- art consultants

Not only can avenues to show your work in different places appear, but you are solidifying your base and broadening your network. Once again, you'll hear news and gossip that will be helpful. And you'll pick up more supporters—people who want you to succeed and who will be there for you when you have your gallery opening.

If you have the money and a support group, you don't have to wait for a gallery. You can have your own show.

The well-known Hollywood director and acting teacher Milton Katselas rented a vacated art gallery in

Santa Monica and gave himself a show. A consummate and gracious salesman, Milton had 120 paintings on display and sold 92 of them! He pulled out all possible plugs—had a staff working around the clock. He flew critics and art experts in from around the country. I was brought in from New York and saw that Milton really knows how to sell art. Not the least of his talents is his ability to relate: upon meeting my Italian husband for the first time, he brought up his own Greek heritage, noting that my husband was from Fellini country and, in the midst of that clamoring opening, took the time to establish a bond. He immediately won the heart of yet another fan.

Volunteer to help at benefits. Offer to speak and bring along your work. Bob Crewe donates his work to AIDS charities because it is a cause about which he cares deeply. In his case, I suggested he focus on donations in one field because artists are overrun with requests for charity donations. Limiting himself to AMFAR (the American Foundation for AIDS Research) allows him to build on that support while expressing his personal views.

Because he was successful in another field, it was appropriate for him to host his own show, which he did somewhat reluctantly because he is shy, but it was enormously successful. People whom he had helped over the years, like Burt Bacharach, Dionne Warwick, and Tony Bennett, came and supported him. That party led

to a group show in the lobby of Hollywood's chic Directors Guild building and finally a one-person show at the Earl McGrath Gallery.

The wheel keeps turning. You are limited only by your imagination and ambition.

Summary

You don't have to wait for your first gallery showing to get your work seen. Some steps you can take:
- ❑ Prepare your work for photographing.
- ❑ Get good, professional slides.
- ❑ Register your slides.
- ❑ Show your work in other venues.
- ❑ Take advantage of other professionals, such as those in real estate and design.
- ❑ Hold your own show.

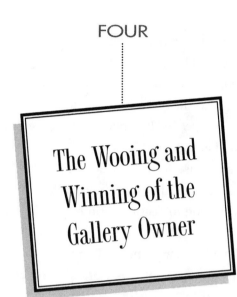

The Wooing and Winning of the Gallery Owner

Think of it as a romance.

You are out to win the heart and mind of a dealer who will be the first to show your work professionally in a gallery. During my many years as a successful gallery owner I have been wooed by some of the greatest artists and seducers in the world.

A couple of successful art Romeos immediately spring to mind. Texas-born Terry Allen, then a student at the Otis Art Institute in Los Angeles, who has since shown at the L.A. Louver Gallery and writes music with David Byrne (Talking Heads) visited my Los Angeles

gallery with a friend and fellow student. They were funny, cute, and bright. I thought of them as Frick and Frack, and they sparkled so much that I didn't want to miss the chance to get to know them. Their styles and personalities opened the door for me to look at their work and offer them a show.

Another artist, Tom, was eager for me to visit his studio and courted me with flowers. The flower box had an invitation to visit the studio, and the artist sent a uniformed chauffeur and flashy Cadillac limousine, outfitted with champagne and lunch. I had a great afternoon. Unfortunately, his work did not measure up to the style of his courtship, but he did get my attention.

Before Steve Martin became a world-famous comedian, he exhibited his art in my gallery, or rather he held an "Invisible Art Show," parodying the current art trends by doing an "Emperor's New Clothes" kind of show. He courted me by buying art out of several of my shows, which will make points with any art dealer.

Mark Kostabi spotted my gallery because of the flags put up on the front by Martin Mull, advertising an exhibit of his paintings. Mark offered me the most amazing "men as machines" drawings I have ever seen. He offered to leave them overnight and I sold them all—to important clients like Aaron Spelling and Douglas Cramer.

Sometimes, getting discovered by a gallery owner

seems like plain old luck, but that is almost never the case.

New York artist Susan Schapira once sent me slides featuring a series of flowers. Her package happened to arrive the day I was curating a flower-themed show and needed one more artist. Her desire to be shown serendipitously met my need, and she wound up as one of the artists in an important New York show. Susan couldn't have planned that in a hundred years. She may have been lucky in her timing, but she had also taken care of business. She had good slides, she had chosen a gallery suitable for her work, and she found me the right day. Plus, she has a friend, Andrea Possner, a journalist at the *New York Post,* who was willing to write about her, which was very helpful as a seduction.

> Each gallery owner feels he or she has the best art gallery in town

These creative spirits used their imagination to separate themselves from the pack, but instead of relying on personalities and gimmicks, most artists must pay more prosaic dues.

Each gallery owner feels he or she has the best art gallery in town. Each has a special preference and each is the boss and remains autonomous in his space. The gallery bears his name—remember that.

So, it is imperative to be respectful and follow the rules:

•Artists must send slides, cover letters, and résumés to the galleries in which they are interested.

•Artists identify simpatico galleries by attending opening after opening and developing networks.

•Each gallery owner feels he or she has the best artists, so don't insult the owners with something out of their realm of understanding. Often, they are frustrated collectors whose collections have grown too big for their homes, so play into their personal acquisitiveness. Get them to love your work.

•You should go to each of four or five galleries you are interested in and make a profile of the dealers: whom he shows and whom he doesn't show. If, for example, the dealer has been around for years and shows only blue-chip artists like Willem de Kooning and Roy Lichtenstein, or only dead artists such as Edward Hopper or Georgia O'Keefe, chances are nearly a hundred percent that he wouldn't show your work, or even look at your slides. So, pick a relatively new gallery, with new or emerging artists or an unformed stable, and plan your attack.

•Pick a gallery that is suited to your art. Sophisticated art galleries have a much looser attitude toward nudity, ugliness, or racial issues (as in the work of Jean-Michel Basquiat) than neighborhood street fairs. People making love, shown in graphic detail, might

attract no attention in a gallery in Los Angeles, while at the nearby Beverly Hills outdoor art fair a nude will attract negative comments.

It's all relative. If your work is conservative or features flowers and churches, find a place that specializes in that kind of imagery for conservative collectors.

Let's say you've done your homework and found that your work would fit well in the Louis Newman Gallery in Beverly Hills. Start dropping by the gallery and chatting with the staff members, who are friendly and talkative (remembering always to be nice to people, whether you are going up or down the ladder of success). Find out when the next important opening is and attend. Dress well, and plan to stay a while. The staff will probably be too busy to talk to you, but just hang out until someone interesting comes along to talk to. Get into the chatter and excitement. Meet the artist, and look over the dealer. You are not yet ready to make your move; the dealer will be selling and will be annoyed by any disturbance from an artist. So, don't push. Just get an idea of who he is, his availability, and so on.

Pick a gallery that is suited to your art.

The day following a gallery opening, go by the gallery and see if you can leave your slides. Although the staff and owner are usually wiped out following an

opening, they are waiting for comments and support, so it can be a great time to make your move. Ask if you may leave your slides with a self-addressed, stamped envelope. Ask if you may pick up the slides after the owner has seen them. Bring flowers for the secretary or the owner and find out if the owner is willing to make a studio visit. Don't hound the owner, but keep going in.

•As an artist, you must learn to recognize dealers who would be attracted to your work. Learn to identify the taste of the gallery owner and conduct the courtship with persistence and patience.

> Successful artists, at the very least, stimulate interest in other people.

Sometimes artists back off too quickly. Sven Lukin, an art star in the sixties, asked me to see his work, but when I did not return his call immediately, he did not follow up. I realized he was ambivalent about second success (he was very successful as a sculptor before), and his pride had stopped him from pushing again.

Life seems to indicate that people who achieve early success are often shot down, and it is how you handle the second success that determines longevity in your career. People seem determined to take potshots at winners—it's part of our society; we not only want to win, but we want everyone else to lose. So, be nice to people

on your way up, because you'll probably encounter them on your way down.

Working artists started with the necessities—good slides, cover letters, recommendations, and résumés—but remember that these pieces only helped to open doors; they did not guarantee a gallery showing.

Try to imagine what it is like to be a dealer—paying a huge rent, wooing collectors, and being bombarded constantly with requests from artists who want their work hung. Sitting in the privacy of your studio, surrounded by your own beloved pieces, makes it difficult for you to understand how a dealer feels facing daily bills, as well as the onslaught of artists and their materials.

Successful artists, at the very least, stimulate interest in other people. After all, collectors are the most important ingredient in the selling triangle in that they provide the money. Successful artists know this. They are also aware of the crucial role of the dealer. Amateurs or unsuccessful artists tend to think only of themselves. My own example of falling on the floor with stomach cramps and having an artist get down on the floor with me to show me his slides is humorous, but true.

It's easy to get bugged about this, but try not to get paranoid with the dealer. It isn't personal. The dealer is not usually intentionally abusive—just too busy. I recall an art dealer who once lost three—yes, three—invitations to an opening. The artist kept checking by phone

and re-delivering invitations. Then, the dealer failed to attend the opening. That artist was entitled to be miffed, but instead she sent the dealer flowers with a note saying she was sorry she missed the opening and would she come by for a private showing and a glass of sherry. The dealer (probably overcome with guilt) did visit the studio, which led to a show and an ongoing relationship from then on.

Because dealers see so many slides and so much work, it helps to make yours stand out. As I have discussed in Chapter Three, the quality of your slides is extremely important.

If you are sending slides to a gallery owner completely cold, a great cover letter or résumé can sometimes turn the trick. L.A.'s George Herms created a résumé that looked as if a pirate had burned holes in it. The résumé itself was a work of art; it was provocative and gave a taste of his collages, which related to treasures, mysteries, and astrological signs. It was an exciting indication that this was a person with imagination who was ahead of the game. Certainly the rest of his work would be worth seeing.

When I started painting, I was invited to a party at Hollywood producer David O. Selznick's Beverly Hills home. I took with me some sketches of nudes I had drawn and left them in my station wagon for the duration of the party. At about one in the morning, when there was only a handful of guests remaining (Jack

Lemmon and Natalie Wood among them), I went to my car, got the sketches, and put them in David's guest bathroom.

Later, David came out of his bathroom and rumbled, "Who put those charcoals in my bathroom?" I froze, because I feared I had gotten some charcoal on his monogrammed DOS towels.

But when I admitted they were mine, he was joyous and commissioned me on the spot to do a painting of his house as a Christmas gift for his wife, Jennifer Jones. I didn't know how to paint houses—only nudes—so I hired someone else to do the painting. David never knew the difference and he and I became fast friends.

Because dealers see so many slides and so much work, it helps to make yours stand out.

This happened before the days of appropriation, so I don't know if he would have complained had he known, but he connected me with all of his friends, who helped me start my own gallery. That incident opened the door to what proved to be a profitable relationship. Once David liked me, he wanted all his friends to do the same, and until he died I was included in all of his parties.

Some years back an artist showed up at New York's Richard Feigen Gallery, brandishing what appeared to be a gun and demanding that the staff members look at

his art or he would shoot them. Obviously, I don't recommend such an approach in these days of drive-by shootings, lest the artist wind up among the obituaries instead of in the art section, but he did get their attention.

Underlying this courtship, of course, is the attitude that you are bringing a gift, a gift to the dealer, a gift to the world.

The next step is persuading a gallery owner to present this gift for you.

Since you are the wooer of the gallery owner, it is your task to lay the groundwork. Once you've identified galleries best suited for your work, you need to identify the needs of those owners and persuade them to show them your work.

When you visit a gallery, whether at an opening or on rounds during business hours to familiarize yourself with the art community, use the visits to expand your network. Sign the visitors' book and ask to be invited to the next opening. Ask the person at the door what will be the next major event at the gallery or in the community. Eavesdrop on conversations about other openings, art fairs, and art happenings.

Now, a word about the person at the desk. Sometimes he or she is abysmally ignorant about what is going on in the gallery, whether it is the price of a painting or when the next show starts. One's eyes begin to roll, but don't dismiss out of hand someone who

appears to be a bimbo. About the time you've gotten tired of getting less than lucid answers from a person who seems more decorative than intelligent, you may miss the employee who not only is in touch with what is going on, but who genuinely wants to be helpful. These creatures, too, can become a part of your network.

When you're browsing, don't be too quick to tell employees that you are an artist and want to show your work. They know and indeed are trained to recognize artists immediately. Gallery employees can tell immediately whether or not you are a buyer. At one gallery where I worked, I carried a coder that signaled who was in the shop: one buzz for a VIP, for example.

Sign the visitors' book and ask to be invited to the next opening.

Take time to cultivate the staff while finding out where they fit the hierarchy of the gallery. Is the young woman behind the desk decorative or herself an artist? Is the employee busy on the phone, and you will be considered an interruption? Is the owner keeping an eye out for new artists?

When you're browsing during gallery hours and spot the owner alone, go right up and talk. You are most apt to be able to chat with an owner during the late morning, before lunch. When the dealer arrives in

morning, there are daily duties to be attended to, and the dealer will be distracted and unable to give you time. However, his interest may be flagging as lunchtime nears, and he might be particularly susceptible to a bite of lunch down the street or to a brown bag of goodies and a thermos of coffee.

Common sense should prevail when it comes to chatting up dealers. Greet them at openings, but remember that they are under plenty of stress at the moment and will not have time for idle talk. The purpose of networking is to be known and be seen as a player. You will be respected for it.

Again, dress for the occasion. The point is to look interesting, not like a Brownie troop leader who came in to the city for a day to kill time. No double-knit polyester—ever.

As you make these visits, develop a list of five outstanding galleries. These are galleries that will always be beneficial to know about and are great sources for present and future networking and inspiration. In New York, for example, your list might include the Leo Castelli, Sonnabend, André Emmerich, Knoedler, and the Marlborough galleries.

Develop another list of five galleries. This will be a

list of galleries that might be available to show your work. Often, they will be new galleries, those that have not already built a coterie of artists. The owners of these galleries frequently have spots in shows for newcomers, and they may also welcome the opportunity to discover the as yet undiscovered.

In the beginning, you cannot afford to be as choosy as you would like about where your work will be shown. You may be grateful just to get one picture up in the middle of a group show.

You will constantly be evaluating what makes a good gallery, such as reputation, space, and services.

Reputation. If you are even a halfway good listener, it won't take long to learn which galleries are respected, which galleries aren't, which owners treat you fair and square, which ones don't. Does the press cover openings held by this gallery? Does the owner's name come up frequently in conversations? Do artists get their money on time?

Showing room. Good galleries have private viewing rooms. Louis Newman in Beverly Hills has an excellent system for selling. His salespeople move in the main room, warming people up. Then Louis shows up and, like a good car salesman, takes them into his viewing room for the closing. It is a special room, with a black velvet rack and curtain, where the customer is served a little sherry and a great deal of attention.

When a person gets ready to buy, he wants to know he is going to be treated well, and Louis sees that he gets special treatment.

The Salander-O'Reilly Gallery in New York has a back room that is even more impressive than the gallery space in front. When you are invited in, works by masters are pulled out for your perusal. It is a sharp gallery in that it shows the work of people who are well-connected in other fields. Joby Baker is married to collector/songwriter Dori Previn. Robert De Niro's late father was a well-known painter, but was better known as Bob Jr.'s dad. The same with Billy Crystal. John McEnroe is famous as a tennis player, but he was also a salesman at the gallery.

It's oh-so-easy to lose a sale when there is no private viewing room. During the Carter White House years, a deal was about to be consummated in Beverly Hills with Joan Mondale's representative, to hang art in Blair House. The gallery did not have a proper closing room, and Murphy's law was at work that day. At the worst possible moment, the bottled water delivery man showed up to change the bottles of water in the cooler. He wanted to talk to the gallery owner about the water bill, and despite the dealer's best efforts, the bottled water discussion cost the art sale. A good closing room, would have prevented that loss.

Adequate space and services. When a show is over,

does the dealer have room to keep your canvases for several months? Does the gallery have room and facilities to mail art after it is purchased? A place to hold interviews?

The common chatter is that art dealers belong to one of three groups: gays, alcoholics, or women. Whatever the truth—or lack thereof—of such a statement, there is one firm rule for winning the heart and mind of any art dealer—(or of any human being, when it comes to that). *Treat that person and his or her ideas with unfeigned respect.*

The art world is a very small world. Gossip prevails, and no one is immune to it. If you cough in L.A., they'll say you have pneumonia in New York an hour later.

The best advice is to listen with sensitivity. Keep the needs of the gallery owner in mind. Yes, you are the one who is presenting a precious gift, but the gallery owner you are wooing is operating a business on which his livelihood and reputation depend.

Good galleries have private viewing rooms.

As you are pleading with the owner under your breath, "Will you show my work, please, please?" the gallery owner is also silently asking questions:

• Has this work been done before?

• Does this work appeal to me? Am I touched viscerally?

• Will a show of this work bring publicity to my gallery?

• Will critics find this show worthy of consideration?

• Will they write about it?

• Is this artist known in the community and thus able to bring in some sort of following?

• Is the work salable?

Even when the dealers feel positively about what they see, they are evaluating your staying power. Are these fifteen paintings all you will do, or are you in a position to commit yourself to the long haul? Douglas Chrismas of Ace Gallery in New York and L.A. wants to know if the artist has a support group. Maybe it is apparent to the dealer that you aren't a good business person. Artists rarely are. That doesn't have to be a problem if you have a significant other to pull you through the tight spots: a mate, a support system, a job in an art-related field.

What cannot be said too often is to imagine walking in the other person's shoes. Be sure you are familiar with what the gallery stands for. It is a waste of time to try to sell male nudes to a gallery that specializes in minimal art. You will simply antagonize the dealer. You

The art world is a very small world.

will not endear yourself to any owner if you have not noticed the sort of art in which she specializes or if you misspell her name.

Because a gallery owner's interests may be different from yours does not mean that he will not be helpful to you.

Say you have fallen in love with the L.A. Louver Gallery in Venice, California, but you know they won't take you because blue chip is their priority. Still, owner Peter Goulds might be willing to help you. Mail or drop off your slides, and then call Peter to say, "If this work isn't for you, I'd like to hear your suggestions. Let me stop by with some lunch and pick your brain."

Or just run in with an attractive tray of food and perhaps a toy from the L.A. County Museum for Beverly Hills art dealer Fred Hoffman's baby and say, "Could you give me some ideas about galleries that might work for me?"

You are walking a fine line as you court the gallery owner. It's not easy to project your belief in your work and your gift while not appearing to be a braggart. You don't want to take no for an answer, but you don't want to be so pushy you drive people away.

If you do sense a real no, move on. You will only antagonize someone who might otherwise appreciate and reconsider your work down the line. Rejection is often God's protection.

The secret is to keep going back. Become a familiar figure, one the dealer will be proud to present.

You've paid your dues and met the requirements. It's your time for a dealer to say, "Yes, I'm ready to visit your studio and see about having an exhibit of your work."

It's time for a studio visit.

Summary

- ❏ Treat the relationship with the gallery owner like a courtship.
- ❏ Develop résumés and cover letters as pieces of art themselves.
- ❏ Develop a list of reputable galleries and gallery owners.
- ❏ Develop a list of galleries that are interested in new artists.
- ❏ Become a familiar figure in the gallery and at openings.
- ❏ Cultivate the gallery staff as well as the owner.
- ❏ Treat the gallery owner with respect.
- ❏ Seek the gallery owner's advice, even if he says no to a show at his store.
- ❏ Recognize the business needs of the gallery owner.
- ❏ Be persistent, but gracious. Know when "no" means "no."
- ❏ Invite the gallery owner to visit your studio.

How to Prepare for the Gallery Owner's Visit to Your Studio

Y ou've done it. A real-life honest-to-goodness art dealer—or representative of a juried show or talent contest or someone from you church or school—is coming to your studio to look at your art. And—naturally, wisely—you want to put your best foot forward, that is, use every wile at your disposal to show off your work at its best.

CHOOSING WHAT TO PRESENT

First, pick out the work you want the dealer to see. You'll need at least twelve to fifteen pieces, and if you have a few more, that's fine, too. But if you have a great many paintings, it's time to do some selecting. Get rid of paintings that are extraneous or not your best work.

Remember Georgia O'Keeffe locking herself in the Shelton Hotel in New York City for a weekend to select the art she would show? By studying the works in isolation, she was able to tell what was important and what was not; she was able to choose a consistent body of work. It was then that she determined to paint flowers and to create large paintings, because no one else was doing that at that time.

Art critic John Coplans coined the phrase "serial imagery." It's an applicable concept when it comes to picking the art you will show. Some of your pieces may have an affinity—take advantage of that by showing them close to one another so that the affinity may be easily recognized. Maybe you spent a weekend in Malibu and every day painted pictures of the sea, like artist Peter Alexander did. Maybe you photographed your body again and again, as Eleanor Antin did when she was on a diet, showing a smaller body gradually emerging.

Richard Diebenkorn painted Ocean Park, California over and over from his studio window in Santa Monica.

He began realistically and then became more and more abstract. Ultimately, he had a beautiful abstract painting, but if you hadn't seen the first ones, you wouldn't appreciate the continuity. Claude Monet painted Rouen. Roy Lichtenstein recapitulated Monet, each painting becoming more abstract, and Matisse sculpted the back of a bronze nude over and over.

Don't group your paintings only according to size or the date when the work was painted. Instead, trust your unconscious. The gallery owner is not stupid; he, too, will pick up emotional vibes and use them as a selling tool.

One way to judge if a painting is good is to turn it upside down and see if it works as an abstraction. Thus, if you get rid of the subject matter, it should still please the eye and get it moving. There's a trick painters use to get your eye to travel around the painting. They start with something to catch your eye at the top left, then move along to the top right, then to something at the bottom, thus creating an imaginary triangle. Some abstractionists have done it with color, for example, with splashes of red. Look at a painting by Jackson Pollock, and you'll see what I mean.

As I mentioned, "figure grounding" is relevant here. That phrase grew out of a method of helping fighter

Don't group your paintings according to size.

pilots maintain focus by teaching them to look at their target, look away, and then look at the target again.

In art one looks at the positive space—that is, the subject—and then at the negative space—the background. The eye moves back and forth.

Think commercially.

This is often the trouble with Sunday painters. They don't know about movement, so they do their favorite flower arrangements, but don't have background or shadow or anything to play off it. The painting is unprofessional, stagnant. A mark of an amateur's painting is that one grows tired of it, whereas the professional's painting is complex. The more difficult the painting, the more it grows on you.

Another caveat is to think commercially. Dealers are motivated by what sells, although they don't always admit it. Look again at a list of the questions dealers are asking themselves when they look at your art:

1. Has this kind of painting been done before? Roy Lichtenstein once told me that when he took his comic book figures to the Leo Castelli Gallery he was really surprised when he saw Andy Warhol's paintings. They were similar because at the time Warhol was doing Dick Tracy and Nancy and things like that. "I was doing comics too and it was very interesting to see [that]

someone else was doing the same thing." Lichtenstein stayed with the benday dot comic figures, while Warhol moved on to the Cambell's soup cans. "Be aware of what is going on," is the motto.

2. Do I like the artist's work? Does it touch me viscerally?

3. Will the critics who count find his work worthy of criticism?

4. Will a show of this artist's work bring in new collectors and/or people who are well-known in the art community? In other words, does the artist have a following?

5. Will this artist make money for me?

On a recent visit to the artist Sierra in her Santa Monica studio to help her sell her art, I found her work was scattered around the studio like a lot of children's building blocks. On one wall were skulls, complete with teeth that she had cast in clay on saws. On another wall was a rendering of a nude Madonna split up the middle over a Renaissance landscape. A third wall contained some lovely landscapes. In the middle of the room were two coffee tables with messages written on them à la Barbara Kruger or Jenny Holzer.

My advice to her was that she look around and decide in what direction she felt she was moving, in which one she felt the most comfortable.

The reason for the clay skulls and the emphasis on

death was that her brother had died recently of AIDS, and obviously she had worked very hard to deal with her feelings. She had gone to an orthodontist and learned how to sculpt beautiful broken teeth out of clay, and she had mounted them on canvas.

She was the artist, of course, and no one can tell an artist what to paint. Personally I liked her landscapes and also felt they would be salable (while the skulls probably were not), because of the resurgence of interest in landscapes in the New York art scene, as in the work of April Gornik. However, what to create is a decision only the artist can make. Sierra may well go on with the skulls. What was essential was that she choose a consistent body of work to show a dealer.

Art is a love affair between artists and collectors.

Be aware, as you make your selections, of the needs of the dealer (or the person from an art rental gallery or museum or talent award group or your church). Art is a love affair between artists and collectors, and every encounter has a spiritual and a sensual side; you will want to put forward those pieces that most nearly meet the concerns of your visitor, but also be prepared to talk about your own favorites and preferences.

You are the ultimate judge. Don't let anyone talk you into something you don't believe in. If an artist

loses touch with himself and paints what the collector or dealer wants, he will lose his soul.

PREPARING YOUR STUDIO

Neatness counts. Clean the place. Take away all the debris and anything that distracts from showing your work to the best advantage.

You'll probably have more paintings than could be used in a show and you can have them stacked around the room—neatly. If you don't have a studio, set your paintings up around the room, and put a portfolio of your work on a table in the center of the room.

Be sure you have two chairs. (If you have more than one person coming, you may want to get more chairs.) Two old-style rocking chairs are ideal. You can get them inexpensively from an unfinished furniture shop, and it isn't even necessary to stain or paint them. What is essential is having a place for your guest, or guests, to sit.

Have your lights in order. Use track lighting or something that will pin spot. If you can't do it yourself, have an electrician come in, and always be willing to trade services for art.

Should you serve something to eat or drink? It isn't necessary, but it's fine to have coffee available. Don't make a big deal out of it; just have it in sight so the vis-

itors can see it is there. If it's an afternoon visit, you might want to have soft drinks or bottled water on hand. (Since many studios do not have running water, you can set up your own bar on the side, with soft drinks, wine, water, and so on.)

If the visit is scheduled for late in the day—say, after five o'clock—you could have some brie or other cheese available with crackers. At that time of day people get low blood sugar, and something to nibble on will revive a tired gallery owner and he'll be more interested in viewing your work.

Dress casually. The impression you make, if this person doesn't already know how you look, is important. Be sure your hair is clean and styled or combed. If you are a woman, wear something that shows off your figure. Jeans and a nice T-shirt are fine if they are clean and pressed. T-shirts usually bear subliminal messages, so choose a T-shirt that says, "Buy My Art!" If you wear sneakers, be sure they are clean. If jewelry is part of your chosen look, wear some attractive pieces. Your appearance affects your attitude and your sense of confidence. When Norman Lear was my client, I used to brush my hair before I got on the phone with him!

Take the phone off the hook before the dealer arrives—unless you are expecting a call from the president or someone else who will impress your visitor. I've seen many sales lost in galleries because the owner answers the phone. Once the buyer mouths "I'll see you

later," he is out the door, probably never to be seen with checkbook in hand again.

ENTERTAINING THE DEALER

Don't ever apologize. You are the host, and the implication is that you have done your best to be ready for this visit. Anything less is an insult to your guest. Besides, an apology may call attention to something the dealer might not have noticed otherwise.

Don't explain your work unless asked. There is nothing more annoying to a professional than being talked down to. A dealer feels he knows everything (well, almost everything), and he certainly knows what he likes. Dealers do not like to be told what they are looking at. What they want in a studio visit is a quiet time to look at the art. One of the joys of viewing art in studios is that it can be done without the clatter and chatter and interruptions of a gallery or other public place. Conversations tend to focus more between artist and dealer in the quiet of a studio.

Recently, I was looking at an artist's slides, and while I was looking quietly she kept talking, talking, talking. Finally I told her that I couldn't concentrate. I needed quiet time to study the slides and she wouldn't let me. She was chattering out of nervousness, and wasn't giving me a chance to evaluate what I was see-

ing. It is best to keep your opinions to yourself with dealers—at least until asked. So be quiet and wait in golden silence—unless of course you are asked a question, which you will want to answer briefly but precisely.

After a while you might say, "Would you like to know how I got into this?" or "Would you like to know something about this piece?" Then have your story ready: the exact moment when you knew you wanted to paint light instead of your favorite cat, the moment you realized in art school that you wanted to make this a lifelong commitment, the moment you realized you would get through your divorce or your wife's suicide by painting. Think this through thoroughly ahead of time so it comes easily and naturally to you.

Have your slides and résumé ready if the dealer asks, but don't push anything at him.

Don't feel hurt if the visit seems brief. A dealer plans to spend about fifteen minutes with an artist, so anything longer is bonus time. If your visitor sits down and stays, take advantage of that time to find out about him or her: what the person likes, what he or she is looking for. While this is not the time to try to sell the visitor on anything, it is money in the bank to have expressed an interest, and it will pay off sometime in the future. Sharing art is always a love affair.

Dealers will usually have some kind of an excuse when they leave if they aren't interested: "I don't know

if it's for me." Or they may say, "I'll be back." If you sense, however, that the dealer is definitely not going to follow up, you could say, "I know your gallery probably doesn't handle this kind of work, but could you suggest someone else?"

The guiding principle to a studio visit is to remember that this is your arena, your proscenium. Like the perfect hostess, you want to make it all happen as ideally as possible.

Summary
Before the visit:
- ❑ Choose similarly themed work to display.
- ❑ Furnish the studio with at least two chairs.
- ❑ Have lighting in order.
- ❑ Dress casually; be clean and neat.
- ❑ Take the phone off the hook or unplug it.
- ❑ Have minimal refreshments available.

During the visit:
- ❑ Don't apologize for anything.
- ❑ Don't explain your art.
- ❑ Observe respectful silence.
- ❑ Have your story ready.
- ❑ Show slides and résumé if appropriate.
- ❑ End the session with graciousness, not anxiety or pushiness.

SIX

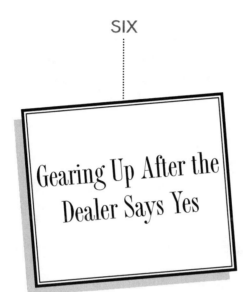

Gearing Up After the Dealer Says Yes

If we hang in with the analogy of a romance between the artist and gallery owner, you may now consider yourself engaged.

You have proposed to the dealer. The dealer has said yes. Now, we just have the prenuptials to work out.

And there is a great deal to be done before the Big Engagement Party—that is, your gallery opening.

Here are some of the decisions to be made and some of the work to be done before you move your art from your studio to the gallery for the Big Night.

- Setting the date and time of the opening.
- Design and approval of the invitations.
- Development of mailing lists.
- Creating an up-to-date biography.
- Creating press kits and press releases.
- Contacting and cultivating art writers and art critics.
- Developing a publicity campaign.
- Developing an advertising campaign, if any.
- Pricing the art.
- Handling shipping.
- Handling insurance.
- Handling business details, such as invoices.

You may be surprised to know that the more professional the gallery, the less paperwork will be involved in setting up the arrangements. As the novice, you will look to the gallery owner for leadership. He is the one with the experience on how to open efficiently and properly. He plans and hosts openings all the time, and this is your virgin voyage. He should have the journey charted, and you should be able to trust the course he has set.

Sometimes the art dealer will ask you to sign contracts, but it is my experience that with beginning artists a handshake is enough. You will find out with that first show how things are going to work out between you and the dealer.

Your networking and art gossip pays off here, too. For example, if the dealer does not have a reputation for taking good care of his artists, you should not be surprised if you get burned. Sometimes this is a tough decision for you to make, because you are new and in no position to make demands. You may be forced to decide between a less-than-ideal show—that is, taking a chance on getting cheated—and no show at all. Willem de Kooning had a wonderful first dealer, Charles Egan—except that Bill finally had to sue to get the money Eagan owed him. This sort of horror story happens frequently, and the art world has its share of "the check is in the mail" tales of woe.

Integrity and art dealership are not synonymous.

The San Francisco Bay area painter Tom Christopher tells about the New York dealer who failed to include his promised check with an order, but when Tom called, the dealer said glibly, as if in surprise, "Oh, here it is on the floor." Sure.

Another dealer complained that he was late in getting a check on the sale of a Mark di Suvero. The fish story he got was even more amazing than the one Tom Christopher was served. "A terrible thing happened," the buyer told the dealer. "I didn't want to trust the U.S. mail with a check so large, so I hired a driver to bring it across the country. The driver stopped in Texas for breakfast and while he was eating someone broke into the truck and stole the check from his glove compartment."

Remember the movie *Legal Eagles*, which starred Robert Redford and Debra Winger? That caper (produced for the big screen by Arnold Glimcher, president of Pace Gallery) was based on the Frank Lloyd scandal that erupted at the Marlborough Gallery in New York after artist Mark Rothko died (in 1970) and the three trustees sold his estate at bargain-basement prices to the Marlborough Gallery. When Rothko's daughter, Kate, at last came to her senses, she sued and got back the estate of her father's work, but the percussions rumble on. The Rothko accountant, Bernard Reis, committed suicide, and Frank Lloyd is not allowed in this country.

Integrity and art dealership are not synonymous.

Although we have some 250,000 people participating in the American art world today, it remains a small, one-to-one business—the only business in the world that is still laissez faire. It attracts extremely competitive people, people who are looking for immortality. The buyer and/or the artist must beware, because there are crooks at every turn.

At one L.A. gallery where I was employed, the dealer turned to me casually as the police took him away in handcuffs, saying, "Oh, by the way, will you cancel my lunch plans?" That dealer sold one Robert

Rauschenberg painting five times to five different people. He collected the money each time and avoided jail with a suspended sentence.

Another noted dealer, Frank Perls, was a tough client when it came time to get my commissions on Picasso sales. He claimed always to be on the verge of bankruptcy.

Architect Frank Gehry's charismatic ex-brother-in-law, Rolf Nelson, lived so close to the edge that he had a secret buzzer signal for his staff. One ring meant a VIP was on the premises; two rings meant the police had arrived. I worked at his gallery early in my career and wound up taking paintings in lieu of salary.

Andrew Crispo allegedly murdered his lovers, a tale reported in *Bag of Toys,* a recent book by David France. One dealer specialized in panty-sniffing. Another Beverly Hills dealer used her gallery as a place of assignation—which cost the gallery dearly on at least one occasion when her lover's wife broke all of the store's windows.

However, as a beginner—and despite these grim stories—you will need to look to the gallery owner for guidance for your first gallery venture.

He, one hopes, wants the best for both of you. If your show goes well, it enhances the reputation of his gallery, to say nothing of benefiting his bank account. It does a dealer no good to present a bad opening.

So once the gallery owner has agreed to present

your art, sit down with him and divide responsibilities. If you are both clear about what is expected from each of you, you will avoid unpleasant surprises, such as discovering on Saturday that no one mailed invitations for a Monday opening.

You want to know as much as possible about what to expect in readying for a show—after all, what have you been doing at all these openings if not learning?—but still the owner is your mentor here, and you don't want to waste your time and his, arguing about how things ought to be done. He is the pro; you are the amateur.

The guiding principle is "Never assume." If you hear yourself saying, "I assume Mr. Gallery Owner contacted the *Los Angeles Times* art critic," stop immediately and find out if he really has. Too often "I assume" turns out to be "Nobody did that."

You will want to reach an agreement on what the owner will get as his share of your sales. Most splits these days are 50-50, although in some cases the owner will get 60 percent. For that kind of money, the gallery owner may be agreeing to get you into a museum, to host a cocktail party for you, and to introduce you to galleries and museums throughout the country. Obviously, there are as many variations in division of details as shells at the shore. Maybe the gallery owner promises to show you every two years, as well as arranging for you to be shown in other galleries

throughout the country. Maybe he will split advertising with you or pay for an opening party.

Don't worry too much if the owner seems to under-price your work in the beginning. One artist, who was married to the president of a bank in southern California, was insulted when I priced her pieces at amounts considerably smaller than those she had been receiving by selling to the bank branches. What she failed to take into account was that her sales thus far had come about because of her husband's position rather than because of her talent. In the beginning, take what you can get. A new artist should be so happy to be shown that he practically gives his stuff away. The only audience this particular artist was going to get at the prices she wanted was her mother and a few of her husband's customers. It is important to price realistically so that you don't look foolish when you have to lower prices.

He is the pro; you are the amateur.

In choosing your work to be shown, let the gallery owner come to your studio and help you make choices. Once again, he wants the best show possible, and he is probably more in touch with what the public is buying than you are. Yes, it is your art, your heart, your gift, but try to listen to his advice with an open mind.

He will usually pick out a consistent body of the

same size paintings. It is all right if your work is already framed, although you might want to wait for the dealer's input.

Now that artists are painting smaller because of the recession, you can have unframed pieces stacked around your studio or room with your personal choices in view. In planning for a recent show, my husband pulled out nearly everything he had ever done, including the kitchen sink. We even took works from our own living-room walls and placed them around the room. Next I weeded out his art school drawings, leaving us finally with his finest work from which to make our choices.

What is important is not to have any piece or pieces so incongruous that the rest of your work looks pale or inharmonious. Do *not* include work that is just "okay." Do include what is *outstanding*.

Summary
- ❑ Be ready to start making preparations for your opening.
- ❑ Trust the gallery owners expertise.
- ❑ Reach an agreement with the dealer on profit-sharing and your individual resposibilities.
- ❑ Don't overprice your work.
- ❑ Pick your strongest body of work to exhibit.

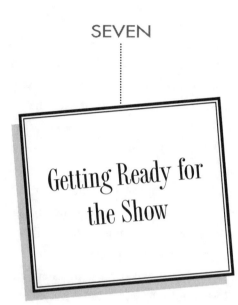

Getting Ready for the Show

It's time to work backwards.

With the gallery owner, pick the date for the opening (whether it is a one-person or a group show) and together make a plan to accomplish all that must be done before the big night.

In my experience a task will take up all of the time available to accomplish it. If the opening is six months down the road, it will take you six months to get everything done. If the owner offers you an opening in four weeks, somehow, some way, you'll be ready.

Ask Tom Christopher. He was called by a San

Francisco gallery to open a show the following day. He did. Not that it went smoothly. He learned later that the scheduled artist had his show pulled because of an outbreak of hostilities; unaware of the late change, several friends of the original artist showed up for the opening, ready to resort to fisticuffs to uphold their friend's honor.

Ideally, I prefer that the artist and owner have about two months to get ready. That gives you enough time to get everything done but not so much that you will waste time on unnecessary jobs.

So, pick the date, put it on your calendar, and create a work schedule. It will help to list everything you need to do on a sheet of large kraft paper or giant newsprint pads, so you will have room to make as many changes and crossouts as necessary. And believe me, there will be a good many more changes than you can dream of. (Artist John White has turned even this task into an artistic opportunity. He makes charts of his schedules and sells them at the Sylvia White Gallery, owned by his wife, in Santa Monica and Manhattan.)

Before you actually hang the show (which will probably be the weekend before the opening), you will need to:

- Select the work to be shown
- Build a mailing list.
- Design and print the invitations.

•Create a press kit that includes your biography, a press release about the opening, a sample (or samples) of your work, and an invitation to your opening.

•Develop a publicity campaign that includes creating the press materials and contacting art writers, critics, magazines, newspapers, and gallery guides.

•Develop an advertising campaign, if appropriate.

•Assemble and make decisions about additional details, such as shipping, insurance, and invoices.

A warning: getting ready for your show is extremely demanding. It demands your time. It demands your emotions.

Although each artist has a different work style, even if you are the kind of person who thrives on crises and impossible deadlines, it is important for you and your sanity to cancel all extraneous and unnecessary events the week before the show.

> Getting ready for your show is extremely demanding.

Chances are you'll offend just about everybody you know just before the opening, because friends and family are not used to having you so busy with something else that you are not available to talk with them the way you usually do.

Memorize this statement and practice saying it: "I have an important show opening, and I won't be avail-

able until after it's over. Forgive me, but I hope you'll come to the opening because I will need you there." If your friend offers to help, say a quick yes, whether it is to bring cheese and dip, or be a gofer the night of the opening.

The above statement is double-edged. It drills a broken-record technique into your own consciousness: "Deadline, deadline, deadline."

Equally important, you are enlisting your family and pals to help you meet your goal to have a terrific opening. Everyone likes to be invited personally to an art opening, and most of us are delighted to be needed. Every time you say to a friend, "I need you there," you have added one more person to an unwritten committee of people who are going to throw their efforts into helping you have a successful opening.

Just as building a network by attending gallery openings is part of your job, your task now is to get ready for a spectacular opening of your own. Preparing for the opening is part of your job as an artist.

SELECT WORK

Once the commitment is made and the date for the opening chosen, you'll choose what work will be shown. This is true whether it is a juried show or a one-

person show, because which work you pick will affect all your other decisions, such as the picture that goes on your invitation and the emphasis in your press release and biography.

The gallery owner will help you make the decision about which pieces to show. Set your work around the studio (framed or unframed, much as you did on his first visit), and together pick the pieces that you both believe will make the most impressive presentation to art collectors and buyers.

The gallery owner will guide you in the next steps: how he wants the work delivered to the gallery, whether you will be in a group or a one-person show, and what kind of announcements will be sent.

The dealer will tell you what your share of the costs will be, and you may be asked to sign a simple contract. Try to have this clarified as soon as possible to minimize misunderstandings.

MAILING LISTS

The gallery where you are showing will have a mailing list that will form the basic contacts, but you can also go to other galleries and ask for copies of their lists. Many dealers are surprisingly generous. They don't feel threatened by sharing lists, because they believe their own

clients will remain loyal to them even if they buy something of yours.

You can also get mailing lists from museums. For example, the Los Angeles County Museum of Arts has five different departments, all of which have separate lists. Outside New York, it is more difficult to develop mailing lists; Los Angeles suffers because fewer art critics are located there, with fewer publications based on the West Coast.

You will of course have your own group of supporters, friends, and family, but unless you married into the Kennedy or Rockefeller family, you'll need more than your close chums.

Bright lights on the West Coast professional horizon are such critics as New York's Peter Frank, who brought a new dimension of professionalism to art reviews, just as Christopher Knight has done in the *Los Angeles Times*.

Both men have stirred up controversy, which is great, because we in the art world love to fight about our favorites. I saw how hungry people are for art ideas when I held a series of art lectures in New York that included speakers like Clement Greenberg and Arthur Danto. It was like the old days when artists hung out at the Cedar Bar on University Place and fought passionately about art and chased women.

Other sources for your mailing list are the AACA (American Art Critics Association. Toby Crockett, [213] 469–5310) and the Art Dealers of America (575

Madison Avenue, New York City 10022, [212] 940–8590). Both have complete lists of galleries. Each early August, *Art in America* puts out a yearly international listing which includes an exhaustive list of United States galleries and lists some international galleries as well.

Art magazines to check regularly for additional addresses are *Art in America, Artforum, Flash Art, Art News,* and *Tema Celeste.* A recent arrival is a magazine called *Coagula.* Janet Preston is the major writer, and the publication is like an artistic geographic tabloid, with lots of gossip about who is doing what, which galleries are folding, and so on.

Build your mailing list.

Check magazines regularly, but if your budget doesn't permit subscriptions, plan to browse at the library. (Even that is getting more difficult, with so many libraries limited in the hours they are open.)

Check your local papers for announcements and ads. For example, the *New York Times* carries reviews and news on Fridays, while the *Los Angeles Times* has news in its calendar section. *The Village Voice* and the *L.A. Weekly* also have complete listings. Make calls and find out which newspapers provide free listings, and be sure your show is acknowledged.

I also check publications to see who is taking out advertising space—if a gallery is advertising, it means it has some money to spend. Also, you can often identify

new galleries, which you can add to your mailing list, as well as checking to see if there might be a gallery interested in your work.

Use your imagination to expand your list even further. Do you belong to a church? Do you have children in school and can you get a PTA list? Go through your phone book to see whom you might have forgotten. Don't forget the people you do business with. Your grocer will come to your opening because he wants to support you and he wants your business. Other possibilities include:

•Museum councils.

•Parents of youngsters in your children's dancing classes or Little League.

•Art dealers in the yellow pages.

•Charity organizations.

Whenever you meet someone new in the art world, make a file card and put his or her name in a box or in your computer so you can invite him to your next opening.

INVITATIONS

The best invitations are 5″ x 7″ postcards with your work on one side and the necessary information about the opening—your name, the gallery, the address, the date (including the year), and the time on the other

side. If the gallery is located in a complicated place, include a tiny map, as well as a fax or phone number people can call to get more details. According to art dealer Ivan Karp, as a teenager, Peter Frank made a collection of gallery announcements, which he subsequently donated to his alma mater, Columbia University.

One reason postcards work well is that they are cost effective. Sometimes you can get bulk rates; besides, that busy gallery owner with stacks of invitations on his desk may be more apt to read your message if he doesn't have to open an envelope.

Color announcements are not necessary. Color triples the cost, so unless the image is dependent on color, using a color illustration is a waste of money.

You may want to try for humor, or if your work is particularly difficult, you could show a picture of yourself doing something extraordinary. John Baldessari's invitation for his first show with me was a poster picture of himself standing in front of a palm tree with an inscription under it that said, "Wrong." Invitees got a triple treat: they saw what John Baldessari looked like, and they were exposed to his humor and what they might expect in terms of irreverence.

Richard Shaw, a San Francisco ceramist, showed a picture of his wife and kids in front of an old pickup truck, in which they looked like Depression-era squatters escaping the dust bowl. Comedian Martin Mull's

invitation showed a falling ladder with paint spilling all over a white canvas. The caption read, "Did I call at the wrong time, Morris?"—the reference being to Morris Louis, a stain painter whose work looks exactly like the Mull "error."

There are bad announcements. An ambitious artist friend in New York sent an announcement card that claimed five dealers represented him throughout the country. There was no picture of his work. Worse, he listed places like the Ontario Museum, which does not actually exist. On other occasions I have called sources given on résumés, to find that they were fraudulent. Don't lie. The art world is too small.

Too much wordiness on an invitation is also a killer. Some galleries go so far into fancy or chic lettering that the point is lost, and those of us over forty can't even read the tiny print.

On the other hand, an outstanding invitation or announcement can leap out at you. I was so taken by computer artist Trici Venola's picture of Marilyn Monroe as Mary Magdalene holding the baby Elvis in clouds that I not only made a point of attending the opening but I promoted her work on my radio show.

Leo Castelli made his reputation by sending out silk screen posters. Larry Gagosian in New York still does. It's appropriate in his case, because he is aiming for blue-chip people whose kids will hang his posters in their bedrooms. He once sent a Warhol poster—one of

his tennis-shoe paintings. I saved and framed it because it was so well done, but in most cases the high cost of printing posters is prohibitive and those large envelopes are one more hassle for the dealer. The gallery generally pays for the postcard and the cost of mailing.

Add the invitation to your time line with two elements in mind:

1. The invitations should go into the mail at least three weeks in advance of the opening.

2. Allow enough time before printing to create the card and get approval from the gallery owner.

Check with the printer to be sure he has time in his schedule to fit in your work. (Add a couple of days on to whatever your vendor tells you. The printer may not lie deliberately, but if his press breaks down, there you are with unprinted invitations and no place to go.) Before you make a commitment to the printer, check prices with more than one vendor; you will be surprised how much they can vary. If an independent printer is experiencing slow times, you may be able to pick up a bargain on your printing costs.

BIOGRAPHY

Your dealer will need a one-page press biography to give dealers and collectors.

Your biography will, of course, include any place

you have shown, such as your son's school or the restaurant down the street that has hung one of your pieces. If any of your work has already been purchased, include a list of collectors, as well as a statement of intent. ("My aim is to show the horrors of war." Or "My intent is to show the changing role of women.")

Find someone besides yourself to write your biography. A trade at an art school can work nicely, but if you are really ambitious (and lucky and talented), you may find an established writer who will talk about your work. Willem de Kooning used Harold Rosenberg as a voice, and Clement Greenberg became the spokesman for Jackson Pollock, who was a relatively inarticulate person. The value of Rosenberg's and Greenberg's voices was immeasurable in the effect on the careers of these two artists.

As a serious artist, find a critic who appreciates your work and cultivate him. Take him to dinner. Listen to his ideas. Find out what his knowledge of art history is and in particular what period he is most interested in and how compatible that is with your work.

When you go to openings, identify and seek out art critics. Christopher Knight is a wonderful critic, as are Robert C. Morgan, Kim Levin, Jan Butterfield, and Eleanor Heartny.

Peter Frank is another critic who has come West. Bored with being a New York celebrity, he decided to

start over, and he is highly sought after in the L.A. critical desert.

Whomever you find—a professional writer or an art student—be prepared to tell your story: "Why I paint what I do." Be specific. Back up your theories with facts and examples. I remember my reaction to a Willem de Kooning show at the Whitney Museum when I suddenly had a great understanding of the level of appreciation those around me had for his work. Maybe your story will be about the instant when you saw your daughter in a particular light and knew you wanted to paint her again and again.

Writing your biography is not something you can do yourself. You need a writer's fresh eye to put your work in perspective.

PRESS RELEASE

A press release is necessary. Its most important function will be as a mailer to art critics and writers and to magazines and newspapers that carry art announcements.

The press release should be as simple as possible, usually one page long, double spaced, with wide margins. It will have the basic Ws of journalism: Who, What, When, Where, and Why. It should be sent out two to three weeks before the show.

I get dozens of press releases weekly, and the ones that get my attention are those with the simplest explanations of facts: What is happening? Where is it happening and to whom? Why is it important for me to be there?

The press release may be a piece of white stationery accompanied by a folder that includes salient pictures and facts. The press releases that I most quickly throw out come from public institutions like the Los Angeles County Museum of Art, which sends page after page after page of boring adjectives with significant facts lost in there somewhere. Better to include a separate straightforward fact sheet that allows the reader to quickly grasp the import of the release.

Sending a press release is not the end of your responsibility with the press. However, don't call the editor or writer and ask if he received the information. He doesn't want to be interrupted. Only if you run into him or her can you ask. Do, however, keep after the listings editors.

Most editors and writers don't lose your release on purpose, and if you can keep a cheerful attitude while your previous release lies neglected on someone's desk, you will have another professional in your corner.

Before that release goes out, give it a tough proofreading. I once saw a press release with the name of the president of the United States spelled incorrectly. Surprisingly, it is those seemingly easy bits of information that often trip us up.

And be sure to include the name and phone number of a contact person at the top of the release. If an editor is attracted by your release, he doesn't want to spend the next hour trying to find someone at your gallery to get information from.

Finally, if any celebrities are planning to attend, alert the press with a phone call. Be sure to say, "Famous Person is expected . . ." Then, if he fails to show, the journalist will understand that you spoke of intent rather than making a promise or commitment. This is only useful for coverage on the Society pages.

PUBLICITY CONTACTS

You want everybody who might print something about your show to get the press release: editors, writers, critics, television personalities, and so on. (This is in contrast to invitations. You want everybody who might come and buy something or just admire your work to get invitations. Thus, you will send many more invitations than press releases. The rule of thumb is about a ten-to-one response on invitations; that is, invite ten people; one will probably show up. If you want a hundred people at your show, send a thousand invitations.

ADVERTISING

The difference between advertising and publicity is that advertising costs actual dollars while publicity depends on efforts you make (even though costs are obviously involved there, too). Look for newspapers and magazines that offer free listings, and don't take out ads when you have nothing to advertise. That is just a kind of name dropping that offers no reward. Your gallery owner will be invaluable in helping you determine whether you should invest in advertising.

SHIPPING

If a gallery is going to show an unknown artist in another city, the gallery will usually pay for shipping one way; that is, you will pay to get your work there, and the gallery will pay to send the unsold work back to you. This is one of the agreements that you want put in writing before you deliver your work. For example, some galleries pay for all shipping, while others do not contribute at all. This is a negotiable item, but if you have to pay for shipping, don't feel you are being cheated.

Some galleries will have other shipping requirements. Some galleries do not want the work to arrive until the day before the opening, while others want it a

week ahead of time in the event they want to repaint or adjust the installation.

Check it out. Be flexible. Then add the dates—those agreed on with the shipper, the gallery owner, and so on—to your schedule.

INSURANCE

In most cases your work will be insured by the gallery, but don't just make that assumption. Ask. If your work is hanging in a restaurant, it is probably insured by the restaurant. Ask.

We had a theft of some of Roman Scott's small pieces, which were taken off the wall at an opening. The thief showed good taste in his larcenous choices, but fortunately insurance covered the financial loss. The deed, however, points out the importance of using special museum hanging devices when you are showing in a public space.

Most of the other materials you need are pretty mundane; for example, you can pick up invoices at a stationery store—you don't need any fancy printing jobs.

You and the gallery owner may be planning other activities, such as a private cocktail party for collectors. Of course, you will add the tasks surrounding these events to your time-line schedule.

Summary

Between the time when the gallery owner makes a commitment to show your work and the day you move your art to the gallery, you will need to perform the following tasks:

❑ Create a schedule.
❑ With the gallery owner, select the work to be shown.
❑ Develop a mailing list.
❑ Create, print, and mail invitations.
❑ Create publicity materials: biography, press release.
❑ Contact writers, critics, and other relevant art experts.
❑ Perhaps place advertisements.
❑ Assemble other materials, such as invoices and price lists.
❑ Plan refreshments for the opening.

EIGHT

Hanging the Show

So you thought you'd been busy in the weeks that you prepared for the opening of your show? Those days will seem like a holiday compared to the days in which you actually set up the show.

In most cases the opening will be set up Sunday through Tuesday, with the opening anytime between Thursday and Saturday. You'll have only two or three days to get everything ready. Obviously, there are exceptions to every best-laid plan, but we'll talk here about the way events are most likely to happen, and you (and your helper friends) will make adjustments according to the

needs and demands of your own gallery owner and his schedule.

While most gallery owners are going to give you only a weekend to get ready, you can count on more time if the show is at a museum—you might even get a leisurely week or two or even more.

Because many galleries are closed on Monday, the dealer will probably have the show that preceded yours taken down on Saturday night, leaving two days to hang a new show. Some galleries will remain dark a week preceeding a show in order to get the place painted and the new show properly installed. Whatever the policy of your gallery, it will never be enough time. So as the last work of the show before yours is hauled away or put into storage, be ready to spring into action.

God forbid that any of your precious time be lost!

If you live in the same city as the gallery, you may have a friend with a truck who'll help transport your work, or you may want to hire professional art movers. That decision will probably depend on how financially comfortable you are—most beginners have to transport their own paintings. If your show is going to another city, check to find which shipping companies are good at transporting art. In Los Angeles, we have Banner, as well as Cart and Crate, which you may recall was start-

ed by then starving artist Richard Klix, and his wife, Eugenia. Talk to the owners—they make deals. ADA, Burlington, and Black Truck are companies that transport art across the country, with specific scheduled stops, every month. Check with them early on, because if you can get on their calendar, it can be a major money saver.

Last-minute artists may have to use air freight. These artists take the stretcher bars off, roll their canvases, and either carry them on board or have them shipped by air freight.

When you get to the gallery for your weekend of hanging, you'll probably feel more like a carpenter or caterer than an artist. You'll need a tool chest that includes everything from a flashlight to the essential yardstick. If the gallery is in an unattended public space, you will need safety devices, such as T-bars or an alarm system.

And because you may wind up with a good deal of dead time on your hands while you wait for the dealer or an assistant to show up, you'll want some sandwiches and beer or coffee for you and your patient helper pals.

If you anticipate being stuck by yourself for any long periods of time, come prepared with an art book or art magazines—God forbid that any of your precious time be lost!

When you take your work in, your first—and most

fun—task is to place the pieces where you think they should go.

Simply said. Less simply done.

Inevitably, when you get to the gallery, you will find you have to change things from your original plan. The rooms are not the way you remembered, despite your visits ahead of time. The lighting is different. You'll find a light switch on the wall where you had planned to put a painting. Anticipate a great deal of work with lighting; it's one of the most important areas, where you'll need the most help.

Never mind that the rooms are not as you envisioned them. That's part of the fun of being an artist: making changes that make your work look good.

The rule of thumb for placement is to put a large piece against the back wall. If your paintings are small, you might instead hang two or three pieces on the back wall, and put five or six on the other walls. If you have many small pieces, you might put some high on the wall or over the door, louver style. Imagine you have a square, and then place your pieces in that square. Making a diagram first will help with placement.

One painting should go in the window. And be sure to make a sign with your name on it for the window. Some galleries are so elitist that they won't want you to have anything in the window—they'd prefer a blank wall—but if at all possible get a piece of yours and your name in the window so it can be seen by street traffic.

Remember that pedestrians or people passing by in cars have only a few seconds to register what they see, so put out something really striking. You could have your own signature in large letters on kraft paper, or have a calligrapher make a sign with your name on it.

I've had people come to my gallery because they had seen the signs outside. New York's abstract expressionist Ray Parker brought crowds into the gallery because people recognized his painting in the gallery window.

Back to the gallery. Sometimes you'll find something that looks great in a small area, say a large piece that almost butts against the walls.

Let's talk about trompe l'oeil effects—deceiving the eye—where the painted surface looks like something else, as in the paintings of the nineteenth-century artist William Harnett. There might be a realistic, life-size picture of a door on a wall that will bring the visitor out of his reality and into yours by tricking the eye and suspending belief. Trompe l'oeil effects help the viewer make an unconscious leap and connect with something you've already thought out.

The way we react to paintings is all visceral.

Details in art that reflect architectural details, such as painter Lowell Nesbitt's molding paintings, which reflect the moldings on New York streets and buildings,

connect the viewer's eye from the outside world to the space of your work.

At the Museum of Contemporary Art in Los Angeles, I noticed architect Arato Isozaki's design of triangular walls, which carried out the triangular shape of his staircase. It's a lovely thing to see.

If you have paintings with a Renaissance perspective, you want frames that enhance it and pull the viewer in. At your gallery hanging, you want the work with the really deep perspective at the far end of the room, so choose a painting that will pull people into the room with its depth.

If you have serial imagery, like Diebenkorn's Ocean Park series or Roy Lichtenstein's cows, it's fun for a viewer to discover that continuity, so place the pictures side by side. The way we react to paintings is all visceral, and this reaction can be enhanced by the way the paintings are hung. Ivan Karp, owner of the O. K. Harris Gallery in New York, says he can feel his skin crawl and his heart constrict when he views a really good painting. And remember Peter O'Toole's intense emotional experience in *Lawrence of Arabia*—an orgasm—when he saw Van Gogh's painting?

Sometimes there's an affinity of styles, a spiritual connection between pictures. So don't group only according to size or the date when the work was done, but according to what goes with what in your subcon-

scious. People are intuitive; they will pick up those emotional vibes and enjoy your show even more.

Another rule of thumb is to hang paintings just below eye level. Of course, there are exceptions. Joe Goode had a show at James Corcoran's art gallery in Los Angeles. He hung all of his pieces so low that you were startled when you came into the room and were instantly questioning why he had done this. He did it, of course, to shock.

However, generally you try to hang things a little lower than eye level. Whose eye level, you ask? Michael Jordan's, say, or Elizabeth Taylor's? Yours? Your spouse's? Make your choice a comfortable one, based on the height of an average man, so viewers can look at the painting without raising their eyes.

> Try to hang things a little lower than eye level.

Ed Ruscha once had a show at the Ferus gallery in L.A. with only one painting—it depicted the Los Angeles County Museum of Art going up in flames. He isolated the area in front of the painting with a velvet rope so that you were forced to look at just that area. He further emphasized his intent by not allowing liquor to be served in that room.

Such minimizing, or cutting down on the number of paintings, so there is more white space, can be extremely effective.

Don't mix your media. If you have a special water-color but your main show is oils, put the watercolor or anything under glass in another room. Maybe it can go in a back room, or perhaps the dealer will let you hang it behind his office desk.

If you have prints, never put them in the main room. They simply create a scattered impression. The only artist I know who gets away with that sort of thing is Jonathan Borofsky. His shows have all sorts of mixtures, because he looks at his art gallery as his subconscious mind, and so he has bits and pieces of everything from his life in one room. Don't mix works under glass with work on canvas or acrylic, because there is a different kind of involvement in them. Works of oil on canvas are the more pleasing ones, because the viewer feels he can touch them and thus has some sort of sensual contact with the artist.

The important thing is to be consistent. My friend Tom Christopher had a show in New York across from the Carlyle that included cityscapes of New York, as well as ordinary tools. He separated the paintings, hanging the cityscapes upstairs and the tools downstairs. It would have been less expensive for him to hang them together, but I thought he was very smart to

**Don't
mix your media.
Be consistant.**

separate them. Although they were done in the same painterly way, one group had nothing to do with the other.

Keep your framing or matting consistent, too, whether it is a particular frame for your oils or whether you have chosen strip molding. Mixing frame styles makes you look amateurish. You may be an amateur, but there's no need to look like one.

Don't hang your paintings on the wall with wire, because then the painting will come out from the wall and create a shadow. Instead put two nails on the wall and hang the stretcher bar directly on them, flush against the wall. Be sure your stretcher bars are strong—you don't want any collapsible paintings.

After you've given placement your best shot, the dealer will want to see what you've done. He'll probably be in to see how your work looks and whether you have placed it properly. Or he may take a more active role and suggest how to hang each piece.

The dealer's viewpoint is valuable because it has the objectivity you lack. Sometimes, for example, the artist crams the room too full, while the art dealer realizes it is better to minimize the room to get the effect of a single painting surrounded by white walls. (White is almost standard for gallery walls.)

The last couple of hours before the opening are usually devoted to placing the lights and the spots. In most

cases the gallery has a couple of energetic people on hand to help, but just in case, be prepared with a couple of backup people of your own.

One last task: Go home and dress beautifully, like an art piece. Give yourself enough time—you wouldn't want to miss your opening.

Summary

- ❑ Get your work to the gallery on time.
- ❑ Take plenty of tools, food, and help.
- ❑ Be flexible.
- ❑ Don't mix media, framing, or styles.
- ❑ Put a piece of your work and your name (maybe in signature form) in the window.
- ❑ Present yourself as part of the opening scene.

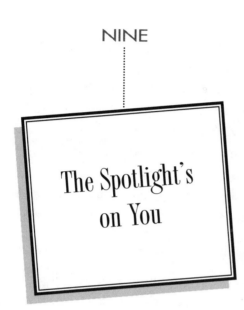

The Spotlight's on You

Poor Cinderella! One of her great misfortunes at the prince's ball was that no one that no one knew who she was.

No such tragedy or case of mistaken identity for you! On the night of the opening, you (and your art) are entitled to be the center of attention.

Revel in it. Enjoy. Like the loss of virginity, it is a once-in-a-lifetime experience.

Most shows run one month, although I don't consider that an adequate amount of time. The opening itself will probably be from 5 to 8 P.M.; you should plan

on arriving about ten minutes after the announced starting time—dressed of course in the style of the persona you have chosen: with clothes and hairstyle and accessories that proclaim you are the artist.

Just as important as your appearance is your attitude. Remember that tonight you are sharing your talents with your family, with your friends, and with the world at large. It is a time to mix pride and humility judiciously. Leave your fights with your wife or mate or significant other outside the door or at home in the garage.

Your self-esteem must be at its highest. If this is a problem for you, do whatever helps you feel your best: have your supportive mate at your side, spend an afternoon meditating, put on your prettiest frock or a family heirloom—it doesn't matter what your technique is—this is not a time for false humility.

If you have any friends who are celebrities, urge them to be at the opening; they will add luster to the evening.

The gallery will look its best too, and the owner will have brochures and price lists readily available. Ask a couple of congenial friends to be there right from the beginning. In practical terms, they are almost co-hosts and can give you moral support, as well as seeing that you are not ever left to roam unattended during the evening. In contrast to the past few months, when you have been gallery hopping on your own, bring your

family and a support group of chums who know how all-important this evening is to you.

No matter how uptight you feel, be friendly and gracious. Have a story readily available to fill dreaded dead air. If someone asks why you picked green for the face, tell him why: "It reminds me of Jawlensky and the fauves" or "The model vomited during the sitting." Such chatter and conversation become part of the relationship, a reminder that art is an affair. Some artists become so nervous or hostile before openings that they fail to show up on time or they drink too much. Instead, luxuriate in the fact that you have all these people who have come to see you. It's a bit like getting to attend your own funeral, except that you are alive to enjoy the accolades.

No matter how uptight you feel, be friendly and gracious.

Be available to the dealer for introductions, and enjoy being a star. Artist Roy Lichtenstein is enchanting at this. I watched him at his retrospective at the Guggenheim, and when people told him they liked his art, he smiled as if he were hearing these words for the first time. Remember that while what people say may sound gauche or trite to you, their intentions are good—it is only that they lack articulateness, not goodwill.

If you can afford it, it's nice to serve food. A few

good cheeses and crackers will do just fine. Yes, you'll get some crumbs scattered about, but little harm is ever done. Other artists and guests may have their little ones tucked under their arms or slung over their backs, and you can't help fretting that they might destroy the art, but nothing like that ever seems to happen.

Circulate. Meet as many people as possible.

It's good to have some designer water, soft drinks, ice, and inexpensive domestic wine available—in some parts of the country we are lucky enough to have a group of stores called Trader Joe's, which with a little guidance will help you choose tasty *and* inexpensive wines. Ideally, the food and drink should be placed in the center of the room, but once again flexibility is the law of the day. You can keep serving simple by covering a desk with a tablecloth or a white sheet and using disposable glasses. Get one of your chums to roll up his shirt-sleeves and play bartender. Artist/actress Sierra counts actor John Philip Law among her pals, and he not only came to her opening but added to the excitement by doubling as celebrity bartender.

The food and drink issue is crucial enough that you need to look for alternatives if you run into problems. A friend of mine in Orange County had an opening at a school where alcohol was not allowed. His fiancée, a soap opera star, invited all her friends to meet and ride

together to the opening on a leased bus. She served champagne and hors d'oeuvres on the bus, and it was a most festive affair.

We were able to add a classy note to our New York openings when we discovered Carolina Slim, a homeless man who gladly played New Orleans jazz for us. He was talented, glad to get out of the subway for a few hours, and appreciative of the nominal fee ($200) we paid him. It was a win-win situation.

If someone rich is giving the party, let them have their way. The late Orson Welles wanted me to show his girlfriend's art. She was quite good, and when Orson was with her, he suddenly no longer was an actor but an art dealer and enthralled us with stories of Ernest Hemingway and the days of art dealing in Paris. When Orson's friend had her show, it included a catered dinner in a courtyard, given by what was then the hottest restaurant in Los Angeles, Ma Maison, with owner Patrick Terraill catering.

Whatever others might choose to do, it's your night to skip the drinks. You don't want your faculties dimmed in even the smallest way. Save your toasts until later.

Circulate. Meet as many people as possible. In particular, if you see a person you have seen repeatedly at openings, this might be a good opportunity to find out who he is. If he's a collector, the contact can only enrich you. If he's a ubiquitous party-goer, be friendly but

move on quickly. Keep your hidden subtext—*you want to sell art*—in mind.

Some dealers don't agree with this point of view and discourage contact between the collector and the artist. They don't want the artist to get close to the collector, for they count on their trained salespeople to do the selling, but it has been my experience that it is good to have the artist around as much as possible. I think many collectors who buy a piece of art are looking for a tie-in with the artist—a shared experience, if you will. The more a buyer knows about the artist he is buying, the better it is.

Sometimes work is actually sold out at an opening. Red dots are placed on the pieces that have been sold, and green dots on those that are on hold. Artist Kenny Price sold all of his work at an opening at James Corcoran's L.A gallery in spite of the fact that it was almost impossible to see the work because of the crowds. But generally, don't expect to sell out during the opening. It has happened; it does happen; but this night is a party rather than a serious viewing of art. Often viewers have a hard time seeing the work at all because there are so many people crowded in, and even collectors have a hard time getting attention. Never mind. The people who care are taking notes and will be back if you are persistent. You and your friends are identifying those who seem interested, and you can invite them to

return at a quieter time. And you can be sure the dealer and his staff are collecting the names and numbers of prospective collectors so they can call and invite them in for a private time.

The opening night is really a tribute to the art, and people are enjoying seeing their friends, maybe former teachers or classmates, and their presence is a matter of support for you as the artist.

Some sales will depend on the crowd you draw. Art is a luxury item, something people buy to feel better about themselves and to feel more powerful. I have a philosophy about why people are buying art at different times, and an awareness of this can help you be a more skillful salesperson.

Don't expect to sell out during the show.

1. People in their twenties love art, especially that done by their friends, but they think it will always be around at inexpensive prices, so they don't buy it. They enjoy it.

2. People in their thirties are often married and thinking about status. They want to buy art that will reflect their good taste and impress their bosses.

3. People in their forties are looking for something to do with their mates besides golf, so they start remodeling their homes and/or find a hobby. And collecting art is a great hobby for people to do together.

4. People in their fifties and sixties are looking for immortality, such as having their names on museum boards and buildings.

5. Folks in their seventies—well, they're like they were in their twenties—they're back to the sheer love of art with no hidden agendas. Their egos are not involved with collecting. If they buy, it is for pleasure and love of art.

Videotaping the opening is becoming increasingly popular. Not only is a video nice as a remembrance, it helps you get another perspective on the way the gallery looks and the way you look, as well as reminding you of some of the people who were there that you want to follow up on. Also, for safety's sake, it offers a visual record if anything is stolen. However, videotaping has its disadvantages: the camera takes up space and can get in the way, working against attention on the art.

EVENTS BEFORE AND AFTER THE ACTUAL OPENING

These days more and more activities are being created around openings. These events are especially important because they allow a prospective buyer to make a personal connection with the artist and provide an opportunity for the prospective buyer to look at your

work without a Looky-Lou spilling champagne on him.

In most cases the gallery owner will repeatedly call the person who seemed interested to invite him for a private viewing.

Some owners have begun having pre-opening parties. William Turner in Venice, California, invites a select few to come early on the day of an opening. Such an invitation makes the collector feel special and more open to your work. This is far more effective than asking a collector to come after the show has opened, when he can clearly see what work has not sold.

Get someone to host a dinner party for you after the show. Not only will you be too excited to go quietly home after the opening, it will cement interest in your work. Be sure to include the dealer at the party, a couple of collectors, some beautiful couple seemingly in love and any others who seemed especially interested in your work at the opening.

L. A. gallery owner Jan Turner often has a party for ten at a Thai restaurant following the opening. For whatever reason, artists seem to love restaurants where they eat with their hands. To digress even further, Ivan Karp claims one reason he loves artists is because they are always good cooks. At the beginning of his career, artists always served beef Stroganoff; today, he says, they serve pasta and sun-dried tomatoes.

Jan Turner includes collectors at her dinners, as well as their mates and other friends. Arrange for the artist to be seated next to the most important potential collector. It's really a charming event, with the artist feeling special and more networking and art-speak going on. Frequently suggestions and connections are made that affect the rest of the show positively.

Another increasingly popular activity is arranging for the artist to give talks at the gallery while the show is running. This is another opportunity to invite special people to a more intimate setting.

What these extra activities mean is that the two or three hours of the opening are only one part of your show. It has been your presentation of your gift, your night to shine, and the beginning of the rest of your life as a professional artist.

Summary
- ❏ Have a positive attitude.
- ❏ Use your friends as co-hosts and bartenders.
- ❏ Circulate.
- ❏ Serve food and drink.
- ❏ Do not necessarily videotape.
- ❏ Plan activities that will take place before and after the actual opening.
- ❏ Enjoy.
- ❏ Learn.

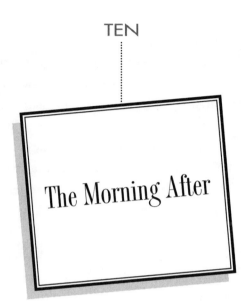

The Morning After

The morning after your opening—good, bad, or indifferent—has a good deal in common with a hangover. You hate to have the glories of the evening end. You treasure each compliment, rejoice in every sale, fret over what you should have said, wonder if that collector would have made a purchase if you had spoken just the right words.

That's what the morning after a successful opening feels like. It's like being dressed up with no place to go.

Except you *do* have a place to go. And work to get done.

First, of course, you're entitled to a few hours of excited storytelling with friends and/or the dealer: Who came to the opening? Who didn't come? And why not? What went right? What went wrong? What was sold? To whom were pieces sold? For how much? Could you believe what Mr. A. was wearing? And imagine Artist A showing up with his girlfriend instead of his wife?

A good gossip about the event is your due. It's fun, and it's all part of it.

But then it's time to get back to the work of selling your art. Make yourself available to the dealer during the time the show is up. There may be a buyer or collector who wants to meet you and if you're at Big Sur or in Maine instead of a pager away, it could cost a sale. Stop by the gallery as often as possible without driving the owner mad and be prepared to meet with prospective collectors.

Check your notes and memory and friends from the opening. Are there people who expressed an interest in your work whom you should contact? Keep records in a Rolodex, a card file, a trace file, a computer—use whatever method works for you. The 1993 Malibu fires are a reminder to keep double files in case of natural or unnatural disasters. A computer-friendly engineer I know was recently burglarized. His equipment can be replaced but not the six months of work he hadn't saved.

Sit down with the gallery owner and talk about the future. Which of your works will he keep in the gallery

after the show closes? What arrangements has he made for your work to be shown elsewhere—in a gallery or museum in another part of the country? Make plans with the owner to further expose your work: arrange for church or museum groups to come in and see your work. Be prepared to give talks and explain you intent and your story.

Read your reviews. Okay, some of them may hurt— just take a look at the cruel Mark Kostabi review in *Artforum*, "Kostabi's works are so bad that they even subvert the good name of 'bad painting.'" But some of them will be educational.

Be on the lookout for a critic who seems particularly taken by what you have done. Write him a note; cultivate the relationship. If you can find someone who seems to want to write about you, court him just as you courted the gallery owner. Willem de Kooning had Harold Rosenberg. Jackson Pollock had Clement Greenberg. You can find yours.

> Read your reviews. Then get back to your studio.

Most importantly, get back to your studio. This is the first day of your life as an exhibited artist. There is work to be done to grow as an artist, and you have planted the first seeds. It is time to cultivate and, one hopes, begin to reap the harvest.

Summary

- ❑ Don't rest on your laurels—there is work to do.
- ❑ Compare notes with the dealer and friends.
- ❑ Keep double records of new contacts.
- ❑ Talk about the future with the gallery owner.
- ❑ Read your reviews and cultivate critics.
- ❑ Be available to meet buyers.

Museums

Today, in my opinion, museums have replaced the church. They have become the twentieth-century place of worship and the place where people meet and date. Art as a social event started with the Renaissance, in terms of the humanist relationship to vision. But today, like the church, museums have had to become involved with making money rather than being receptacles of our most sacred historic treasures.

Unfortunately, today museums are controlled by the trustees. Trustees are usually a group of patrician busi-

nessmen, political figures, or philanthropists who often have little idea about art.

The museum director, who used to exert an almost godlike power as a cultural visionary, has become an appeaser for the trustees rather than exerting leadership himself.

Gerald Nordland, once director of the Chouinard Art Institute and the San Francisco Art Museum, says the tragedy today is that directors like Philippe de Montebello of the Metropolitan Museum of Art, New York, are no longer cultural leaders, but babysitters for the rich; people who have made their money and have power in government, politics, and industry are trying to buy immortality by being on museum boards. By reading Thomas Hoving's book *Making the Mummies Dance,* you can determine how far museum politics has gone.

Thomas Armstrong, the popular, long-time director of the Whitney Museum of American Art, New York, and now the director of the Warhol Museum in Philadelphia, reportedly was fired because a trustee was upset when his daughter was denied an apartment in the Park Avenue building where Armstrong was on the board. This is just one example of the power wielded by a museum trustee.

Museums, like galleries, come in all sizes and with all levels of prestige.

The curators, who are supposedly experts in specific fields of art history, are often given positions outside their expertise. The system is a mess. Often, curators do not have a broad background in art history. Sometimes they are hired because of their connections or because they can write well. For example, recently Rick Brown was hired to organize a lovely show of Ken Noland's target paintings at the Houston Art Museum, where he had once been the director. Brown was shocked to find many of the curators didn't even know who Ken Noland was, let alone the importance of his target paintings.

There is not enough money to keep museums open on a daily basis and there is little public support. Recently, Michael Shapiro, a midwestern curator of nineteenth-century art, was hired by the Los Angeles County Museum of Art to replace Rusty Powell. Powell was a politically savvy director who moved to the National Gallery in Washington, D. C., where he replaced Carter Brown, who moved on to head an arts cable channel. Rusty was a master at fund-raising and at getting along with touchy museum trustees. Michael Shapiro was not. He was not prepared to raise funds and was tormented by the trustees. He quit after eleven months.

Another major flaw in the system is that museums are forced to have blockbuster shows to bring in money. It's tragic. For example, at the Museum of Modern Art last year it was the Matisse show that drew huge

crowds. The year before, it was Picasso, and this year it is Miró who is drawing attention everywhere and thereby increasing revenue. The drawback is that museums can't afford to have many small, quiet exhibits by emerging artists, because of their extreme need for money.

Still, as an artist, you'll want to get into a museum show. As New York painter Alexis Rockman puts it, "I want to have a level of impact socially and culturally." Today, instead of talking art, students hide their ideas and their canvases for fear someone will steal their ideas and they won't get to a museum. This means fewer gallery showings of new young artists.

Museums, like galleries, come in all sizes and with all levels of prestige. The goal of getting hung in a museum is accomplished in much the same way as getting hung in a gallery. In most cases, you will be a more viable candidate for an exhibition if you have had a legitimate gallery show.

So, despite the restrictions and the politics of museums today, what is the best way to show your work there? Be outrageous. Gronk, a Hispanic artist, burned his entire collection of paintings in front of the Los Angeles County Museum of Art. He got a show. Keith Haring painted graffiti on the walls of New York City subway stations. He also got a show.

Get into the museum system. Follow the advice of Gerald Nordland and make friends with curators if pos-

sible and send them slides of your work. Look for museum talent shows and try the art rental galleries.

The Art Rental Gallery at the Los Angeles County Museum of Art (LACMA) makes a point of looking over every application, and makes studio visits once a week. The members of the selecting committee are sharp ladies who have a serious interest in picking the best. They often know who is worth seeing before anyone else does. They may or may not have the curator's ears, but they keep their own ears to the ground.

Every year LACMA has a young talent award; the recipient receives $10,000 and a promise that his or her work will be shown in the museum.

Watch for shows that may be open to newcomers.

Use art magazines to become familiar with museum shows for young talent around the country. Watch for shows that may be open to newcomers. Submit your work.

Talk to the shippers who move art. They always know of new museums and galleries that are looking for new artists.

Emerson Woelffer, an old-time abstract expressionist, talks about working as a janitor at the Art Institute of Chicago, then quitting because he was offered a job with the WPA (the Works Project Adminsitration under

FDR). He worked with people like de Kooning and Jackson Pollock, and therefore got known in the art world.

Ross Bleckner, the New York painter who paints AIDS subjects, talks about going to New York from Cal Arts in Valencia, California, and about how his entrance to the museum world came from his dealer, Mary Boone.

Howard Fox, the curator for modern art at LACMA, claims he visits artists' studios at least one day a week. He looks at all the slides he receives. He answers all letters.

The late Henry Geldzhaler, once curator of the modern wing of the Met, made studio visits every Saturday. He discovered, much to his surprise, a synergism occurring. A number of artists were doing the same kind of painting, unbeknownst to each other—Roy Lichtenstein, Andy Warhol, Jim Rosenquist, and Tom Wesselmann. He suggested they divide up territories and each concentrate on a different aspect of what critic Lawrence Alloway termed "Pop Art." The rest is history.

Each museum has its own personality and specialty. The Whitney in New York deals exclusively with American art. It holds a biennial to show the best young

> Each museum has its own personality and specialty.

American painters in the country. However, in recent years, the biennial has turned into a joke. Visitors are stunned to see only one or two paintings among 250 works. Included in the show are machines, works of computer art, video, and everything short of virtual reality. In today's world, it's hard to say where people can go for emotional and visual sustenance.

Chicano artist Frank Romero describes the difficulties of getting into a museum show. "We Chicanos couldn't get recognition. One of the ways we dealt with that was to go back into the streets. We took the idea of Mexican mural painting and we did much more ephemeral work that wasn't made to last. We grouped together and we got recognition. Ours was the only Hispanic Chicano art show they did in the Los Angeles County Art Museum in the past twenty years." Give it all you've got and keep going.

That really is the role great art performs for us. If your work does that, go for it.

Learn to hang out at museum openings. Dealers and collectors will become your supporters, if you ask them for advice—and then follow that advice. In the nineties, make small paintings. The recession is a blessing in disguise. It allows artists to get rid of excess and focus on quality.

You're not Picasso—at least, not yet—so don't overprice yourself. Trade drawings for food. Picasso did.

There are many museums throughout the United

States. Some of them, like the galleries, will be helpful; some will not. You must do your homework, and a good gallery owner can help you do that.

Also, galleries are listed annually in *Art in America* and the *Art Marketing Handbook,* while others are listed in international listings. Just like a good salesperson, you will need to keep track of how and where you spend your time, money, and quality.

Summary

❑ Approach being shown in a museum as you would a gallery.
❑ Use your network of contacts.
❑ Be outrageous.
❑ Befriend a curator.
❑ Be aware of newcomers shows and awards.
❑ Attend openings.

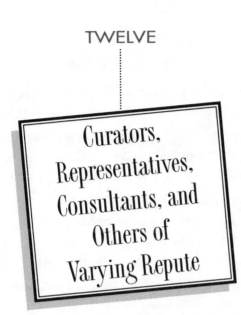

Curators,
Representatives,
Consultants, and
Others of
Varying Repute

A̶s you become better known, you will be sought after. Popularity has it advantages. Free lunches and all of that.

You may feel you want professional help. Some of us are recipe followers. Some of us are not risk takers and are not about to put in a pinch of salt just because the chef at the Four Seasons did.

Here, briefly, are some of the professionals, quasi-professionals, and scam artists you can expect to cross your path. Some are to be cultivated and some are to be avoided. Some will help your career, and some will hinder it.

GALLERY OWNERS

As an artist, you will find gallery owners a ubiquitous part of your life. You will see them at their openings, at other gallery openings, at museums—wherever artists go you will find them on the eternal quest of discovery. They may not be looking for the next Bobby Fisher, but they are looking for the artist who will be a provocative addition to contemporary art.

Art dealers and gallery owners are in the same profession, practically speaking, but an art dealer may work out of his home. The claim of being an art dealer signifies that he belongs to an art dealers' association, has hours (he can say "by appointment only," but that puts him in the consultant business), and has a professional place that people can visit.

Dealers range in importance from the unknown to those who are stars. They will be modest, arrogant, efficient, careless, likable, obnoxious—but whether their galleries are large or small, they are important to you and your future.

Remember that their goal is to make money. They need to be offered art that will bring in customers. They do not want to be wheedled.

What they offer is what is important to you. Do they have room to store your work after it has been shown? Do they have contacts with other galleries and museums that will show your work? Do they have

exposure in the art community? Are they respected? Do they pay on time?

Expect to pay a dealer more than a consultant. He is renting space and guaranteeing an opening and has trained personnel on hand. Dealers once got 30 percent, then 40. Now it's gone to 50 percent and sometimes even 60.

For this, the dealer should promise to show your work every two years, put you in group shows, network with other galleries, and put your work in museums. He may split advertising costs with you, and may pay for the opening party.

As mentioned earlier, there are honest and dishonest players throughout the art industry. Use your art network for recommendations and information on prospective dealers.

CONSULTANTS

A consultant is hired by a corporation or private party to buy or maintain an art collection, as in the David Rockefeller Collection or the Eli Broad Collection. Sometimes they will work for an artist, placing his or her work in valuable collections or even selling to restaurants or hanging art in public spaces.

A good consultant will be brutally honest about everything you do, from the way you dress to how to

promote your art. A good consultant can make all the difference in your career, but they do not come cheap. Expect to pay $100 hourly to $1,500 monthly for a consultant.

A bad consultant is not worth his weight in easels, so if you are looking for someone to help you with your work, it is important to choose a person who is well connected in the art community.

You need to check credentials. Many art consultants today don't have any background. They take a class at UCLA, buy a silk shirt, and print business cards. Maybe they have helped a friend do her house.

A couple of consultants who are really good on the West Coast are Mumsie Nimeroff and Tressa Miller. Tressa curated the Security Pacific Bank Building. Usually an art consultant has a corporate account like AT&T or a bank, although the bad economy has cut back a lot of those art programs. Builders Eli Broad and Norton Simon are among those who have maintained curators.

CURATORS

The curator puts a show together from start to finish. He conceives the idea, arranges the dates, and sends out the announcements. The person or institution for whom he is curating pays him a fee, usually from

$1,500 to $5,000. Curators earn their money. In the case of the Lichtenstein show at the Guggenheim, it took two and a half years to get it together because the work is owned by various people. Likewise, the works in John Baldessari's show at the Whitney Museum were owned by many people who lent their prize possessions to the traveling exhibition for two years.

Jeff Phillips looks for art with a great deal of human interest; he finds people with talent and then shows them in the Hollywood Director's Guild building on Sunset Boulevard.

ART REPRESENTATIVES

When you ask for a representative, it shows you are an amateur. Amateurs fall into the trap of getting reps because they don't want to deal with the business themselves, but a dealer wants to meet the artist and see the work for himself. He wants to feel he made the discovery. Reps are for illustrators, designers, and commercial artists—not artists.

Public relations consultants are more useful. Caroline Campbell represents people—whether they are professional or not—and charges them $150 an hour, with a ten-hour minimum. Her advice includes getting them to advertise in national magazines (there is no point in this unless you have something to advertise)

and getting, say, Peter Frank to write a review. She gets artists shown in Los Angeles galleries and performs a much-needed service.

For a rep to be valuable to the artist, his job is pure and simple: get a show. If he can't do that, he's not worth anything. The only reason to hire someone is to get you a show—not to find other ways to spend your money.

MANAGERS

Manager is a show-business term, perfectly legitimate there, but once again a sign of amateurism in the art world. Peter Max has a manager, who does everything from getting doughnuts for guests to acting as bouncer at a party to paying the income tax. For these services, he takes one percent of all Peter makes.

Mary Fitzgerald is a Los Angeles manager who gets fifteen dollars an hour and mainly helps the artist get organized and set long-term and short-term goals.

Fitzgerald teaches artists how to budget their money, how to determine how much to spend on their careers, how to get slides, how to network and how to make a press kit.

Summary

❑ There are all kinds of people, both honest and dishonest, available to work for you. Before you part with your money, check them out through your art network.

❑ Art dealers are important to you and your future— they are the connection between you and the buyer.

❑ A good consultant can be expensive, but valuable. Choose someone well-connected in the art community.

❑ Curators put together shows for collectors and institutions.

❑ Public relations consultants can be helpful, while having an artist representative can mark you as an amateur.

❑ Managers, like artist representatives, handle the business side of things for the inexperienced or preoccupied artist.

THIRTEEN

Success Stories

Conceptual art star John Baldessari gives the lie to the cliché that those who can't do teach.

Indeed, John's talent developed in obscurity for many years while he taught, first as a substitute teacher in city schools and later at the University of California at San Diego and Cal Arts, to support his addiction to expressing his brash ironic humor through art. His invisibility was the more ironic as his students, such as David Salle, Matt Mullican, and Eric Fischl, went on to find their own places in the sun of the art world.

John walked into my West Hollywood gallery in 1967. He looked pretty disreputable, more like a street person than a college professor—even an art professor. At that time John believed that the mind and body were completely separate and that there was no necessity to take care of his body. (Now, he is on a fitness jag; he has a trainer and wears beautiful clothes.)

His art wasn't presented any better than John was. Nevertheless, although it was dirty and badly stretched, it showed the unique way he looked at the world, seeing everything about him as fit for art. Using print and type, he blipped out truths about beauty and art and truth. His work reminded me of those machines in Times Square and on the old Hollywood Taft Building that spat out the news.

I suspected his work was great, but I didn't know I was getting in on the ground floor of what would be a big swell in the art business—the beginning of conceptual art with an emphasis on photography and lettering, such as we see today in the work of Barbara Kruger and Ed Ruscha.

Before that time John had been trying to get his art seen. He believes art is a conversation, a dialogue. To him that meant he had to get it out where it could be seen. He had tried coffee shops and public libraries, anyplace he could get a showing, but finally he went to New York, where, slides in hand, he went from gallery

to gallery for two weeks, visiting three or four galleries a day.

He hadn't guessed it would be so difficult, and by the time his allotted two weeks were up, he had no takers. As dramatic as fiction, his breakthrough came on the last scheduled gallery visit on his last day in New York. At the Richard Feigen Gallery, he met a young man named Michael Finley, and when Feigen eventually opened up a second gallery downtown, John was shown there— first, in a three-person, then a one-person show. Later, his first European show came about because a friend of his was friends with a dealer in Germany who was just starting out.

John came to me on the recommendation of a mutual friend, poet David Antin, who also taught at UCSD, and the show at my gallery (photography on large canvases and text pieces) helped broaden his audience because of the publicity that surrounded it. Serious art people from the West Coast came to the opening and paid enormous homage to his work, which gave him a great deal of credibility. He was written about in *Artforum, Art News, Art Week,* and the *Los Angeles Times*—all of which helped broaden his audience considerably.

His breakthrough came—dramatic as fiction—on his last gallery visit.

John moved at once to New York, where almost immediately he showed with Ileanna Sonnaband. John recognized the importance of showing in Europe, and his work was shown at the Biennale in Venice and in Germany. He also cultivated collectors, who were invaluable. Once they bought him and believed in him, they had a stake in his success.

One of my favorite stories that John tells is the time he entered his art for a show in Barnsdall Park that Clement Greenberg was to judge. Greenberg had said that one knew immediately whether one liked a painting, although such opinions might have to be given a rationale later. So John entered a painting of Clement Greenberg, which was filled with statements like "Esthetic judgments are given and contained in the immediate experience of art." John's picture was rejected. He notes with amusement that Greenberg indeed knew what he liked.

Now bi-coastal, with his home in Santa Monica, California, and an apartment in New York, the sixty-three-year-old has been described as a nine-to-five artist; he gets up at 6:30 A.M., reads the paper, and has coffee and breakfast before beginning work at 10:00 and continuing until 7:00 or 7:30 P.M.

Hard work and an original talent have combined to make him one of the "lucky" successful artists.

Milton Glaser, a leading designer and illustrator in

the sixties and now again a painter, has described it this way: "Basically, the great art experiences we all have transform what we see in daily life. Great art does that. Whenever you walk through the woods, you say, 'This looks like Cezanne.' Cezanne taught me how to look at the thing that would be invisible to me without him." That really is the role great art performs for us. If your work does that, go for it.

People ask me, how do you know when you are looking at a great painting? Where does the feeling first hit? I think it is a gut reaction. I feel a tremendous calm, followed almost immediately by a strong feeling to either laugh or cry. I feel centered mystically, but at the same time I soar, and think to myself, I could have done that. Often great art seems so simple.

In the case of John Baldessari, I knew immediately when I first saw his paintings that he was doing something important, universal. I loved the paintings but felt I had to stay awake and not get carried away by his strong personality and humor. I felt I was trying to rein in a horse.

That feeling has come to me often, when I sit in a room full of de Kooning paintings, when I see a Magritte or a Jasper Johns flag or an Eric Fischl domestic scene. In my own case, discovering the talents of the then unknown John Baldessari, Robert Cottingham, Don Eddy, Joe Faye, Gronk, Mark Kostabi, Tom

Christopher, or Roman Scott, sensing an artist's genius and then watching others discover the same insights— these are my greatest joys.

In closing, I repeat the often quoted lines by Larry Poons, "Art is not for everyone. It never has been. It never will be. But if you love it like we do, we want to turn you on."